BASEBALL
IN
ALBUQUERQUE

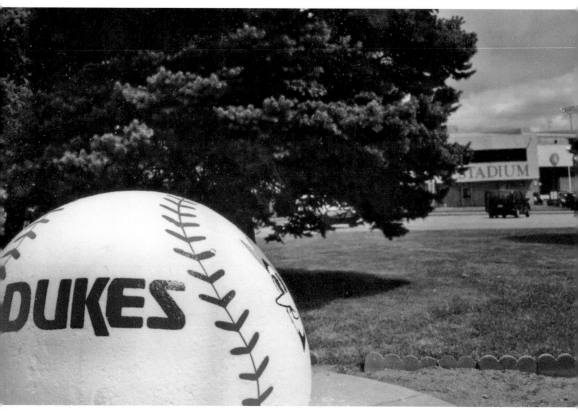

This large, concrete baseball has served as a landmark of sorts for the three baseball stadiums in the "Duke City." Here it sits in front of the Albuquerque Sports Stadium, which was in use from 1969 to 2000. It moved to the corner of Avenida Cesar Chavez and University Boulevard from in front of Tingley Field. The baseball rests in basically the same place today, but now it is in front of Isotopes Park, which was completed in 2003. (Photograph by author.)

FRONT COVER: The first place today's old-timers probably saw a ballgame in Albuquerque was Tingley Field, the venue for countless baseball contests between 1932 and 1968. The exact date of this photograph is unknown, but the bunting may indicate that it was taken during a postseason game—a distinct possibility in light of the team's success during its decade in the Texas League (1962–1971). (Dick Moots collection.)

COVER BACKGROUND: An aerial view of Tingley Field, probably shot by late photographer Dick Kent in a helicopter, shows downtown Albuquerque and the Sandia Mountains in the background. (Dick Kent.)

BACK COVER: Here is a studio portrait of one of Albuquerque's early baseball teams, which were attracting crowds to Traction Park, located within the horse racing track at the territorial fairgrounds a decade or two before New Mexico became a state. (Center for Southwest Research.)

BASEBALL
IN
ALBUQUERQUE

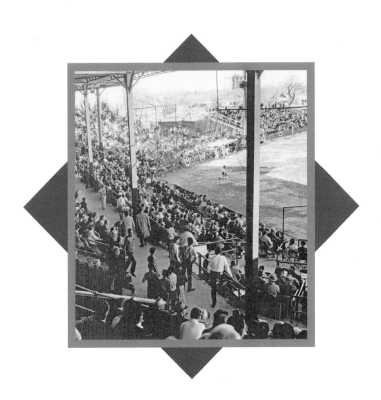

Gary Herron

ARCADIA
PUBLISHING

Published by Arcadia Publishing
Charleston, South Carolina

Printed in the United States of America

Library of Congress Control Number: 2010934681

For all general information, please contact Arcadia Publishing:
Telephone 843-853-2070
Fax 843-853-0044
E-mail sales@arcadiapublishing.com
For customer service and orders:
Toll-Free 1-888-313-2665

Visit us on the Internet at www.arcadiapublishing.com

CONTENTS

ACKNOWLEDGMENTS

Preparing this book was a labor of love for me, and like a successful baseball team, I needed some key players. Among them were the Albuquerque Isotopes and general manager John Traub; the Center for Southwest Research; former Albuquerque Dukes' pitcher Steve Lagomarsino; legendary basketball coach Jim Hulsman; Connie Alexander, Gig Brummell, and the other members of the Albuquerque Professional Baseball Hall of Fame selection committee; Charlie Blaney, Richard Arndt, Terry McDermott, and the other former Dukes/Dodgers I spoke to; and Dick Moots of Rio Rancho, whose dutiful care of memorabilia and photographs of the 1970s was priceless in the compilation of this book. And I also give an assist to www.baseball-reference.com, which had tons of valuable minor-league statistics on its site. Unless noted otherwise, all photographs here came from the author's personal collection.

INTRODUCTION

For thousands of people every year, Albuquerque, New Mexico, makes a neat pit stop while traveling east-west on Interstate 40 or north-south on Interstate 25.

Others probably think of Albuquerque as a place for hot-air balloons, a city of nothing but adobe homes (untrue), a coyote wearing a bandana, a place that Americans need to have a passport to visit (also untrue), the home of Indy 500 champions Bobby and Al Unser and Al's son Al Jr., as well as the site of the memorable 1983 NCAA Final Four—Jim Valvano and his North Carolina State Wolfpack upsetting the "Phi Slamma Jamma" University of Houston at "The Pit." And lately, former Indiana University basketball standout Steve Alford has been leading the Lobos back to national prominence in that same Pit, although it underwent a $60-million renovation in 2009 and 2010.

But Albuquerque has been a great place to play baseball, thanks to the fine weather—winds notwithstanding—and watch it, too.

Baseball has been played here as far back as the late 1800s. In 1885, in fact, a team called the El Paso Blues thought it was pretty good at the game and challenged Albuquerque to face it in a three-game series at Traction Park, a rough baseball field within a horse racing track at the territorial fairgrounds near what is still Old Town.

The Albuquerque Browns accepted the challenge, and a handsome silver cup was crafted in New York City, costing $25. To the surprise of many, the underdog Browns beat the Blues 17-7 in the July 4 opener. The day after, the Browns eked out a 20-16 victory (apparently good pitching was at a premium then as well).

Although the Browns had won the series and a third game was not necessary, the teams played a practice game for fun on July 6, with the same outcome. Albuquerque won this time, 36-12.

Some hearty men from the Atchison, Topeka, and Santa Fe (ATSF) Railroad later built a wooden ballpark in the 1920s at Stover Field, and they named it Rio Grande Park. The ATSF team called itself the Broncos; newspaper accounts stated that the team's best players were brothers Bill and Vince Devine.

Baseball soon took off once Rio Grande Park's diamond and grandstand were built, enhanced by a WPA project in the 1930s. An adobe wall circled the outfield, and in 1932, two weeks into the short-lived Arizona-Texas League season, a worker tacked up a sign that read, "Tingley Field."

Renamed in honor of flamboyant mayor and governor Clyde Tingley, the cozy ballpark in the Barelas neighborhood, a short walk from the Rio Grande Zoo, was home for professional teams through the end of the 1968 season. The ballpark had an adobe facade and a cramped press box, although the late Herman Schuler was not one to complain—it is estimated he watched more than 3,000 games played there, and he later compared the "new" Albuquerque Sports Stadium to the old Polo Grounds. Schuler remembered watching John McGraw's teams play there from his vantage point on Coogan's Bluff, of which Albuquerque Sports Stadium's famed drive-in area reminded him.

Former Brooklyn Dodgers' pitcher Roger Craig was the manager of that Dukes team, then playing in the Texas League. One day, many years later in Scottsdale, Arizona, where he was

managing the San Francisco Giants, Craig explained that Dukes' general manager Peter Bavasi had asked Craig—who had retired as a player in 1966—to be the starting pitcher in the final game at Tingley Field to ensure a large crowd; Craig agreed.

Duke City residents loved their (then) state-of-the-art Albuquerque Sports Stadium on the northeast corner of what was then Stadium Boulevard and University Boulevard Southeast—a great place to spend a summer evening. Still the Albuquerque Dodgers, the Double-A affiliate of the Los Angeles Dodgers, the team featured a parade of some great future major leaguers, mostly Dodgers-to-be, with surnames like Crawford, Buckner, Garvey, Cey, and Lopes.

The team became the Dukes again in 1972, when the Dodgers moved their Triple-A team in the Pacific Coast League from Spokane, Washington, to Albuquerque. A loveable guy named Tommy Lasorda came with the team from Spokane, led the Dukes to the PCL title, and in 2007 he became the first inductee of the Albuquerque Professional Baseball Hall of Fame.

Some great baseball players of the future honed their hitting, pitching, and base running at Albuquerque Sports Stadium, where fans got to see youngsters like Orel Hershiser, Ted Power, and brothers Ramon and Pedro Martinez (and even Jesus, the youngest and least known of the three Martinez boys) and sluggers like Pedro Guerrero, Franklin Stubbs, and Mike Busch—plus four of the five Dodgers named National League Rookie of the Year in a five-year stretch: Eric Karros (1992), Mike Piazza (1993), Raul Mondesi (1994), and Todd Hollandsworth (1996).

The fans may have been spoiled by what they saw playing on that corner; the Dodgers, however, wanted a better facility. They pulled their Triple-A team out of the Duke City after the 2000 campaign and sent it to Las Vegas.

Albuquerque went two seasons without professional baseball until another affiliate switch took place before the 2003 season; and by then there was a spanking-new stadium on the same corner, fabulous Isotopes Park. The Florida Marlins wanted to be closer to their Triple-A team, which had been in chilly Calgary in Alberta, Canada, and decided that Albuquerque fit the bill. For the next six seasons (2003–2008), it did. Baseball fans—not many of them lifelong Florida Marlins fans (the team did not even exist before 1993)—had to be content watching some lackluster minor leaguers save for the Marlins' top pick in 2000, Adrian Gonzalez, now a slugging first baseman for the Boston Red Sox. And even though the Marlins were World Series champions in 2003, Marlins gear was rarely seen around town or even at the new ballpark.

The new regime did not ignore the city's thirst for baseball: exhibition games featured big-league teams in 2004, when the Marlins played their Triple-A club, and again in 2005 when "Major League Weekend" featured a round-robin of sorts among the Colorado Rockies, Texas Rangers, and Arizona Diamondbacks. In 2007, Albuquerque became the first city to host two Triple-A All-Star Games; the city had also been the site for the 1993 contest.

Another affiliate sleight of hand happened after the 2008 season, and Albuquerque fans were delirious to learn that the Dodgers were coming back to town, now nicknamed Dodgertown, New Mexico. (The Marlins, meanwhile, sent their Triple-A club east and quite a bit closer to Miami, setting up shop in New Orleans.)

No, they wouldn't again be the Dukes—Portland, Oregon, had acquired rights to the nickname when it grabbed the franchise in 2001—but they would acquire one of the most marketable nicknames in sports history: the Albuquerque Isotopes, gleaned from (believe it or not) an episode of *The Simpsons*.

THE EARLY DAYS

In 1882, an Albuquerque railroad team traveled around the Southwest, never losing a game. Home games were played at Traction Park, near Old Town. In 1891, the Albuquerque Maroons were the champions of the Southwest. In 1894, the Albuquerque Browns won the New Mexico tournament. Not much else is known about those teams; W. T. McCreight, editor of the *Albuquerque Daily Citizen* newspaper, managed the 1894 team, which had Fred Raymer (age 19) on its roster. Raymer is believed to be the first player from Albuquerque to play in the majors, taking the field for the Chicago Cubs (1901) and the Boston Braves (1904 and 1905).

In his book *A Boy's Albuquerque, 1898–1912*, author Kenneth Balcomb (1891–1979) recalls Dan Padilla organizing a local baseball team, the Grays, and writes, "It took him only half a day to raise the necessary $15,000 by visiting the saloons along Railroad Avenue." Balcomb also describes the annual New Mexico Territorial Fair (statehood would not come until 1912), held at Traction Park, which included a half-mile racetrack and, within that, a baseball diamond.

"A baseball game was held every day of the fair," Balcomb writes. "Since fair week occurred after the national baseball series was over, big-league players were recruited to play with the local team, the Browns, and this provided two good teams and creditable baseball. The umpire seemed always to be Tom Hubbell, the sheriff."

One early Albuquerque-born player to reach the big leagues was Fred Haney (1898–1977). He was an infielder, outfielder, and later manager in both the PCL and major leagues. He managed the Milwaukee Braves to the 1957 and 1958 World Series, winning in 1957. He was inducted posthumously into the PCL's Hall of Fame as player and manager in 2003.

In 1915, an Albuquerque team played in the Rio Grande Association, which folded after the season. In the late 1920s, a Santa Fe Railroad team persuaded railroad officials to donate lumber and ties for the city's first real ballpark, Rio Grande Park, located on the site of an earlier field (Stover Field). In 1932, the city received a $10,900 grant from the Public Works Administration to build an adobe-based ballpark.

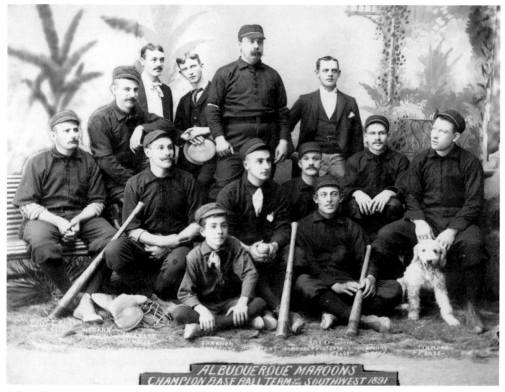

The Albuquerque Maroons were the champions of the Southwest, as this parlor portrait indicates. The youngster in the front center was probably the batboy; the dog is presumably a mascot. (Photograph by Cobb Studios, courtesy of Center for Southwest Research.)

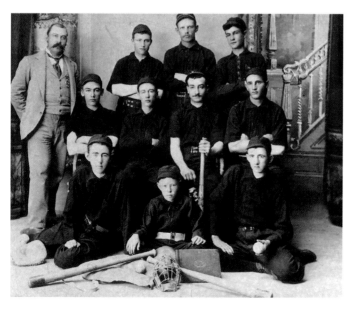

W. T. McCreight, at left in the suit, was the manager of the Albuquerque Browns, who won the New Mexico tournament. McCreight was the city editor of the *Daily Citizen* newspaper at the time and reportedly named his team after the St. Louis Browns. Fred Raymer is on the right end of the second row; seven years later, he played in 120 games with the Chicago Cubs. (Center for Southwest Research.)

Martin Angell was the head coach of the University of New Mexico baseball team in 1906, which compiled a 5-2 record, including a 5-2 victory over the Albuquerque Browns. Five other games were battles with nearby Albuquerque Indian School; the team's finale was an 8-2 victory over El Paso High School. (Center for Southwest Research.)

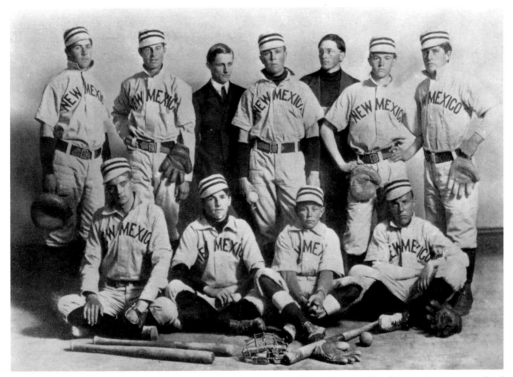

In this undated photograph, it appears the University of New Mexico's athletic department had at least enough money to buy matching caps for the players, unlike previous UNM baseball photographs discovered for this book. Thus, it appears the photograph was taken after 1914, when players wore a variety of caps. (Center for Southwest Research.)

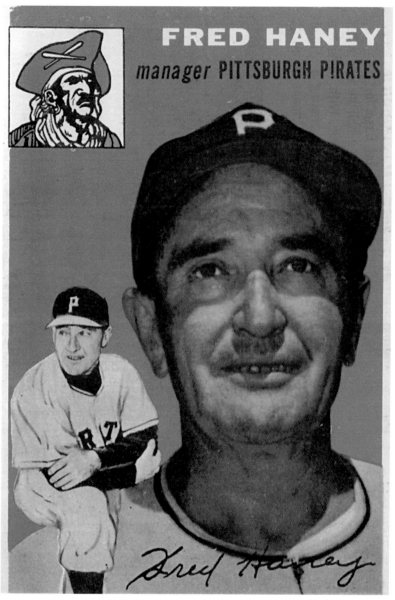

FRED HANEY
manager PITTSBURGH P!RATES

Arguably the most famous baseball player born in Albuquerque, Fred "Pudge" Haney was also a manager, broadcaster, and front office executive. Born on April 25, 1898, Haney played with the Detroit Tigers from 1922 to 1925, when he was a teammate of Ty Cobb. Haney also played for the Boston Red Sox (1926 and 1927), the Chicago Cubs (1927), and St. Louis Cardinals (1929). Most of his career was spent in the PCL, which inducted him into its Hall of Fame in 2003. "Cowboy" Gene Autry selected Haney to be the general manager of the new Los Angeles Angels when they entered the AL in 1961. In 1957, Haney led the Milwaukee Braves to the World Series championship after a victory over the New York Yankees; the Braves made it back in 1958, when the Yankees avenged their loss of 1957. Haney died in Beverly Hills, California, on November 9, 1977. (Topps Chewing Gum Company.)

THE EARLY DAYS

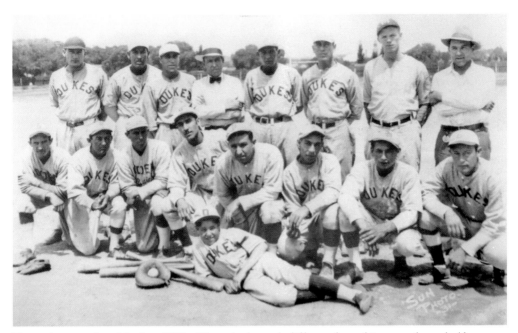

Team photographs of the late 1890s did not look much different from this one, taken a half-century later. It is of the Albuquerque Dukes, but the writing found at the bottom of the photograph is too faint to determine what year it was taken. Because the Albuquerque professional teams were the Dons and Cardinals until 1942 (when a poll of residents determined the name should be the Dukes), it is probably from the 1940s and was shot at Tingley Field. (Dick Moots collection.)

This old postcard is believed to be the 1914 University of New Mexico baseball team, which was guided to a 4-2-1 record by head coach Ralph Hutchinson, then in his fifth of eight seasons at the helm. The Lobos' victories that season were over St. Michael's, the Santa Fe Elks, Albuquerque Indian School, and St. Michael's High School. (Nancy Tucker.)

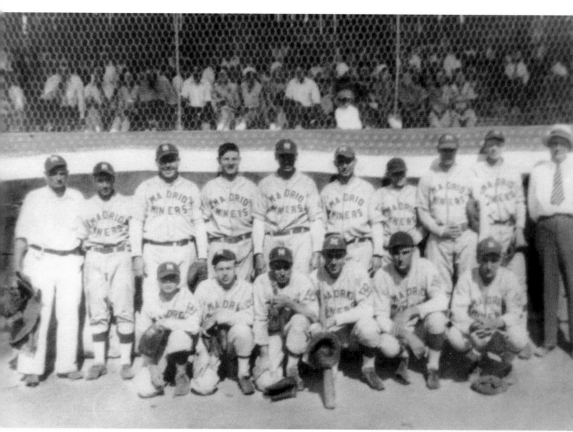

Mining towns throughout the Southwest took pride in assembling good baseball teams to represent them, and Madrid, New Mexico, was no exception. Teams often hired former semipro and professional players to be on their teams and, not surprisingly, some of these men did not have to undergo hard labor in the mines. Raton, Santa Rita, and Dawson were among the mining towns with teams in the 1920s. Raton even had a professional team that played in the Rocky Mountain League in 1912. Pop Stowers, Chief Bowles, Red Garcia, and Lefty Webster were on this 1929 team according to University of New Mexico/Valencia Campus professor and historian Dr. Richard Melzer, who says he believes that organizing baseball teams was a good way to nationalize immigrants. It hasn't been confirmed, but some say the old Madrid ballpark was the first ballpark west of the Mississippi River to have lights installed. (Center for Southwest Research.)

THE EARLY DAYS

2

THAT TINGLEY FEELING

Professional baseball got its start here on April 7, 1932, when the Albuquerque Dons, a farm club of the Mission team in the PCL, beat El Paso 43-15 in a windstorm. The Dons won the first half of the Class-D Arizona-Texas League season, but the league folded on July 24 during the worst year of the Great Depression. The team played its home games at Rio Grande Park (later named Tingley Field).

Playing in the Arizona-Texas League in 1937 as a Class-D farm team of the St. Louis Cardinals, Tingley Field had been restructured with steel through the Works Project Administration and could seat 5,000. The Albuquerque Cardinals were managed by former Gashouse Gang catcher Bill DeLancey, beating El Paso (1937) and Bisbee (1939) for league championships.

Still in the Arizona-Texas League and a Cardinals' farm team, the Dukes were a Class-D team in 1938 and 1939 and a Class-C team in 1940 and 1941. In 1942, the Dukes began the season in the Class-D West Texas-New Mexico League, managed by 22-year-old Dixie Howell. The league folded at midseason because of World War II.

Pro baseball resumed in 1946. The Dukes played in the West Texas-New Mexico League through the 1958 season with three big-league affiliations: the Oakland Oaks of the PCL (1953), the New York Giants (1956), and the Cincinnati Reds (1958). There was a smattering of former and future big-leaguers that played for Albuquerque during that era, including Don Ferrarese; Dick Gyselmann; Ray Hamrick; Hersh Martin, who managed the team from 1948 to 1951; Jim Marshall, future Cubs skipper; Eddie Carnett; Culley Rikard; Lloyd Brown; Eddie Bockman; future big-league managers Bob Swift and John McNamara; Valmy Thomas; and Jack Baldschun.

In 1959, the city was without professional baseball. In 1960 and 1961, Albuquerque became a farm team of the Kansas City Athletics and played in the short-lived Class-D Sophomore League. The most notable future big-leaguers here in 1960 and 1961 included Bill Bryan, Jose Santiago, Larry Stahl, Winston Llenas, and Aurelio Monteagudo. Bert Thiel was the manager in 1960, while Grady Wilson managed the 1961 team.

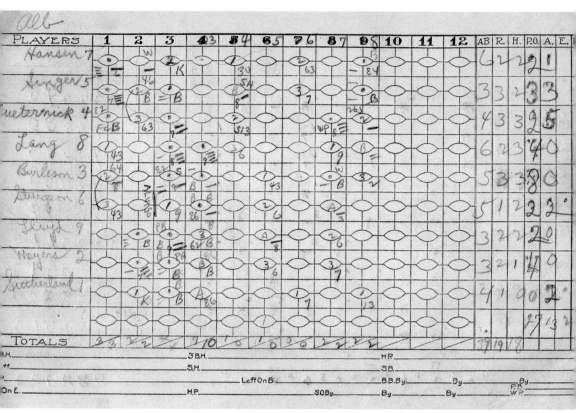

This Albuquerque Cardinals' batting order and score sheet came out of what served as the score book for the 1937 Cardinals and was probably maintained by Herman Schulman, who scored more games played in Albuquerque—mostly at Tingley Field—than anyone else. Albuquerque beat Bisbee (Arizona) 19-11 the day this game was played at Tingley Field. Batting sixth for the Cardinals was shortstop Bobby Sturgeon, who went 2 for 5. A fan favorite, Sturgeon was only 17 when the season began and ultimately made his big-league debut in 1940 with the Cubs, for whom he played five seasons. His big-league days ended with the Boston Braves in 1948.

THAT TINGLEY FEELING

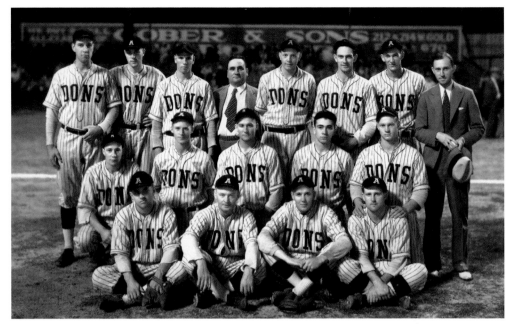

The 1940 Albuquerque Dons amateur baseball team was joined by Mayor Clyde Tingley, the dapper fellow in the middle of the back row. The professional team in town, though, was still the Cardinals, and it remained so until the fans voted to bring back the Dukes name in 1942. Gober and Sons Furniture was listed in the 1935 city directory as being located at 205 West Gold Avenue. (Albuquerque Museum.)

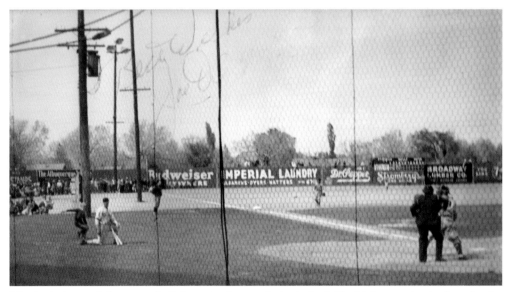

The little boy at left, near a ballplayer in the on-deck circle, is Fred Matteucci, who bought the rights to the Dukes' logo a few years ago. The ballplayer is Joe DiMaggio, who played at Tingley Field with a service team in 1943. Matteucci says the film was quickly developed, and he got this photograph back in time to have "Joltin' Joe" sign it for him. (Fred Matteucci.)

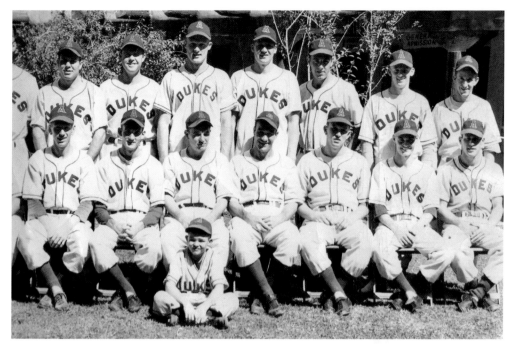

Former New York Yankee Herschel Martin was the player/manager for the 1950 Dukes (who went 89-58). Martin was no slouch at the plate, batting .389. Don Cantrell led the pitching staff with a 20-6 record, and Robert Spence went 16-10. Fred Besana, who had a record of 15-11, was the lone Dukes' hurler to reach the big leagues, playing in seven games for the 1956 Baltimore Orioles. This photograph was taken outside of Tingley Field. (Steve Lagomarsino.)

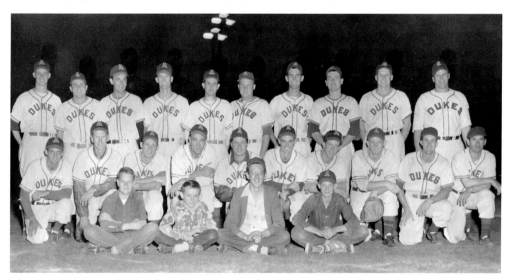

The 1951 Dukes were led by player/manager Herschel Martin, 41, who had an "off year" at the plate (.325) but hit 16 homers. Jesse Priest (19-4) and Don Cantrell (17-14) were the staff leaders; Steve Lagomarsino (10-13) and Robert Spence (11-12) combined for 21 more wins. The team's shot at a third consecutive WTNM title ended in the first round of the playoffs. (Steve Lagomarsino.)

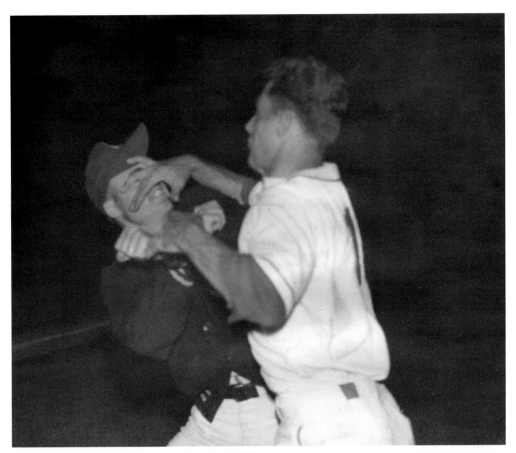

An altercation in a 1951 game at Tingley Field saw Dukes' pitcher Steve Lagomarsino (right) come out of the dugout to battle Abilene coach Jim Melton. Lagomarsino enjoyed his days with the Dukes; he said the team's single players slept on cots and took showers at Tingley Field, essentially living there when the team was in town. (Steve Lagomarsino.)

Jesse Priest was one of the top pitchers for the Albuquerque Dukes in 1951 and 1952, winning 19 games each year. In his words, "In 1952, the owners of the ball club wanted Barbara and me to marry at home plate before the game, so we agreed, and there were 3,631 people in attendance. I pitched that night and won 15-1." (Albuquerque Isotopes.)

Jerry Folkman, seen at left, could play three infield positions or take the mound as needed; he pitched in three of his four seasons with the Dukes, winning 19 games in 1952. He also was the team captain in 1950, when he played in 136 games, batting .301. He played in the West Texas-New Mexico League with Amarillo in 1948 and 1949, playing in 140 and 139 games, respectively. He saw less time with the Dukes, for whom he played four seasons (1950–1953). In the photograph below is the jacket once worn by team captain Jerry Folkman, who began his professional career at El Centro, California, in 1947 at the age of 20. Folkman was an outstanding handball player in his later years.

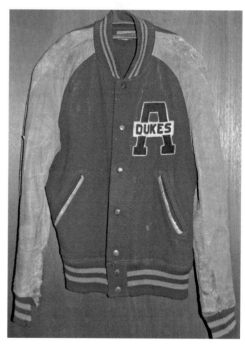

Longtime U.S. senator Pete Domenici was quite a hurler back in the day, pitching for St. Mary's High School (state high school champions in 1949), St. Joseph's College, the University of New Mexico, teams in the Greater Albuquerque Baseball League, and briefly with the Albuquerque Dukes in 1954. "He was a better than average pitcher," recalled Jim Hulsman, the manager for a local semipro team at the time. (J. D. Kailer.)

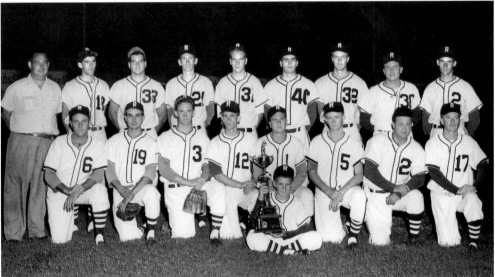

The Rio Grande Lumbermen played in the Greater Albuquerque Baseball League and won the state championship in 1956, qualifying them for a trip to the annual National Baseball Congress tournament in Wichita, Kansas, where they finished in eleventh place. Jim Hulsman, who later earned fame as head basketball coach at Albuquerque High, was the team's manager (far right, first row). Amateur baseball kept real baseball fans entertained for years at the Heights Community Field. (Jim Hulsman.)

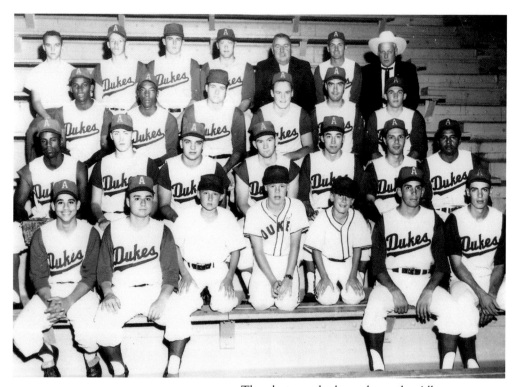

The photograph above shows the Albuquerque Dukes team that played in the Sophomore League, with pitcher Bernard "Gig" Brummell seen third from the right in the second row (and at left). Team manager Grady Wilson led the Dukes from what had been a last-place finish in the season's first half to the second-half title—and the playoffs, where they lost to Hobbs for the league title. Brummell was 6-4 for the Dukes, an affiliate of the Kansas City Athletics, that season. In the top row, the three men to the upper right are, from left to right, general manager Perk Purnhage, Grady Wilson, and team president Tom Bolack. Brummell, now a member of the Albuquerque Professional Baseball Hall of Fame selection committee, played basketball (1958–1961) and baseball (1960 and 1961) at the University of New Mexico. He joined the Dukes after the Lobos' 1961 season, singing for a $1,000 bonus. A right-handed pitcher who grew up in Boonville, Missouri, Brummell spent 1962 with Minot, 1963 at Lewiston, and 1963 with Burlington before entering the military. (Both Gig Brummell.)

THAT TINGLEY FEELING

3

A FORCE IN THE
TEXAS LEAGUE

After a quarter century of playing in various leagues and classifications, not to mention several affiliates, Albuquerque began a decade in the Texas League in 1962 when New Mexico businessman Tom Bolack bought the franchise in Ardmore, Oklahoma, for $35,000. More than 133,000 fans turned out to see their new Texas League team that first season, when the Dukes (70-70), managed by Bobby Hofman in the final year of affiliation with Kansas City, finished third and made the playoffs, going three-and-out in their series with Tulsa. Jose Santiago (16-9) led the league in victories. In 1963, the team began its affiliation with the Los Angeles Dodgers and a handful of players who would make their mark in the bigs—Wes Parker, Bill Singer, Jeff Torborg, and Bobby Cox—were on manager Clay Bryant's roster. Bryant was back in 1964, when the Dukes (75-65) again finished third and were again ousted in the playoffs by Tulsa.

In 1965, with two three-team divisions, Albuquerque (78-62), now called the Dodgers and managed by Roy Hartsfield, won the Western Division and its first of three Texas League championships by defeating Tulsa. Future Cooperstown inductee Don Sutton, promoted after going 8-1 in the California League, went 15-6 for Albuquerque. Bob Kennedy was the manager in 1966, and Tom Hutton, Texas League Most Valuable Player and batting champion (.340) was on the roster, but the Dodgers (74-66) lost to Austin in the rain-shortened league championship series. Former Brooklyn Dodgers' star Duke Snider managed the team to a 78-62 record and a first-place finish in 1967, when there was no postseason. Another former Brooklyn favorite, Roger Craig, managed in 1968, leading the team to a 70-69 record and even starting the season finale—the last game ever played at Tingley Field. In 1969, the first year at Albuquerque Sports Stadium, the team finished in last place (67-69) under manager Del Crandall, who turned it around and led the team (83-52) to a first-place divisional finish and its final Texas League title in 1970. Monty Basgall managed the squad (67-75) in 1971, the team's final season as the Albuquerque Dodgers and the club's last in the Texas League.

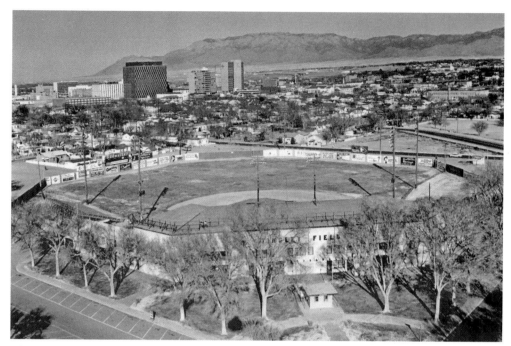

The aerial view above, taken by photographer Dick Kent, gives a good idea of Tingley Field's proximity to downtown Albuquerque. The ballpark stood in the Barelas neighborhood, near the Rio Grande Zoo. Though the exact date of the game photograph below is unknown, judging from the Dodger emblems visible on some players in the third-base dugout, this Tingley Field photograph was taken sometime between 1965 and 1971, when the team played as the Los Angeles Dodgers' Texas League affiliate. The bunting suggests that this may have been a postseason game, a strong possibility in light of the team's success during its years in the league. (Above, Dick Kent.)

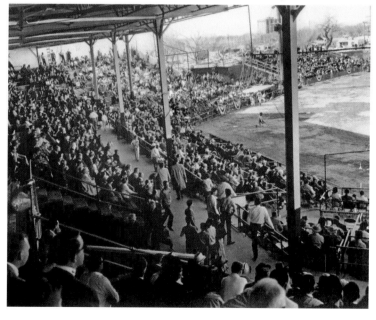

A FORCE IN THE TEXAS LEAGUE

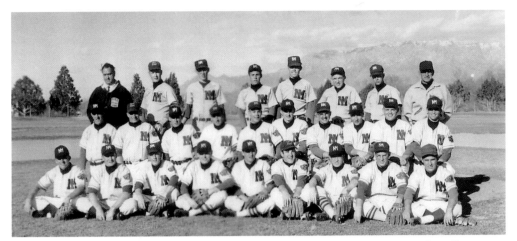

In 2010, the mundane team portrait seen above led to some interesting stories in the *Albuquerque Journal*, where it was first published, mistakenly, as a photograph of the 1962 Lobos, who until the 2010 season had been the only UNM squad to advance to the postseason. Eventually the team in the photograph was revealed to be the 1963 Lobos, a club that compiled a record of 18-16 for coach George Petrol. The 1963 team enjoyed the unique opportunity of playing an exhibition game against the Los Angeles Dodgers in April 1963—a 4-0 Dodgers victory highlighted by home runs from "Moose" Skowron and Wally Moon and 10 strikeouts by future Hall of Fame pitcher Don Drysdale. In the photograph below are the 1940 Lobos. From left to right, they are Ralph Sallee, Bob McAulay, Jim Hinkle, Cliff Fowler, Bill Polk, and Bill Posen. (Above, UNM Sports Information Department; below, Center for Southwest Research.)

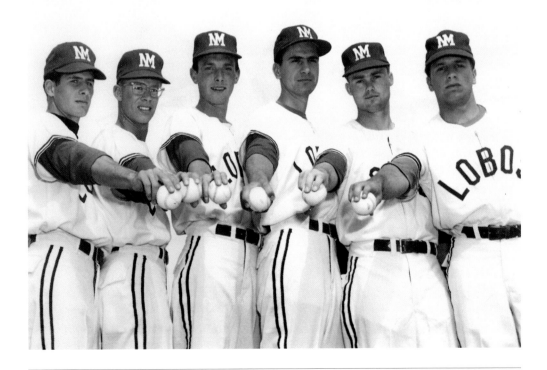

Bob Leigh was the head coach of the University of New Mexico baseball team from 1966 to 1976, compiling a record of 309-212-2, although the Lobos fared no better than ties for second place in the Western Athletic Conference in 1968 and 1970. Leigh was the skipper when Jim Kremmel threw the only no-hitter in UNM history on April 17, 1970, at the University of Arizona. (Dick Moots collection.)

Albuquerque businessman John McMullan played a key role in keeping baseball in the Duke City and served as vice president to Dukes' president Tom Bolack. The two men, credited with being instrumental in establishing the relationship between the teams in Albuquerque and the Los Angeles Dodgers for 35 years, were inducted posthumously into the Albuquerque Professional Baseball Hall of Fame in 2008. Their plaques now hang within McKernan Hall. (Dick Moots collection.)

A FORCE IN THE TEXAS LEAGUE

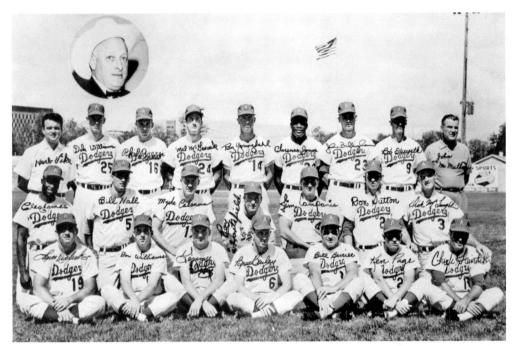

Managed by Roy Hartsfield, the 1965 Dukes, seen above, compiled a 77-63 record and finished third in the Texas League but beat Tulsa three games to one to become league champions. Future Hall of Famer Don Sutton (15-6) had the league's best winning-percentage in his lone season in Albuquerque (second row, second from right). In the photograph below, future Chicago Cubs' manager Bob Kennedy (front row, fourth from left) was the Dukes' manager for one season, in 1966, and the team finished 74-66, which was good for third place. The 21-year-old William Larkin won 20 games that season, yet he never pitched in the big leagues. However, a lot of future Los Angeles Dodgers—Willie Crawford, Jim Fairey, Mike Kekich, and Alan Foster—were on this squad.

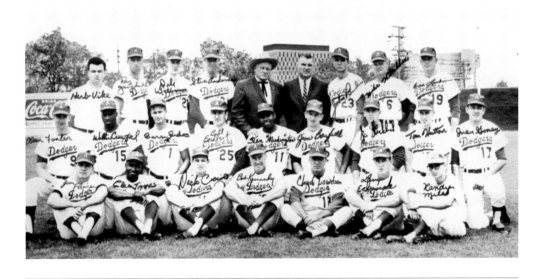

Nobody on the 14-member selection committee of the Albuquerque Professional Baseball Hall of Fame was sure when this photograph was taken, but they could agree on a few things: the men here are pitchers; the man at the far right is either the pitching coach or the manager; and the player to the left of the coach, wearing a road jersey, is possibly a new addition to the staff.

Fans unhappy with the name "Albuquerque Dodgers" were pacified by calling them "Duke's team." In his 1988 autobiography, *The Duke of Flatbush*, Duke Snider mentioned his year-long stint in Albuquerque a couple of times; he had asked the parent club to allow him to have three of his favorite players (Ray Lamb, Ted Sizemore, and Billy Grabarkewitz) moved up from Tri-Cities with him. Snider was inducted into Cooperstown in 1980.

A FORCE IN THE TEXAS LEAGUE

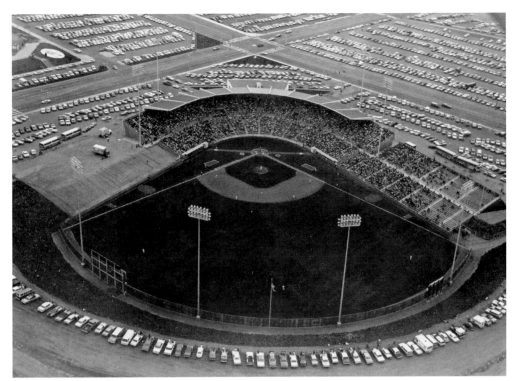

In the photograph below, Joanne Williams from the Albuquerque Dodgers' front office poses by this says-it-all sign outside the Albuquerque Sports Stadium, probably in the early days of the nation's only drive-in ballpark. Of course, drivers often turned on their headlights just before they began backing out to leave, so there was really no need to escort them out. Play-by-play man Mike Roberts would often ask during his radio broadcasts, "Why do they need to see where they're coming from?" In the photograph above, an aerial shot of the stadium reveals a well-attended game underway, as evidenced by the semicircle of cars in the drive-in area and full parking lots outside the ballpark. (Both Dick Moots collection.)

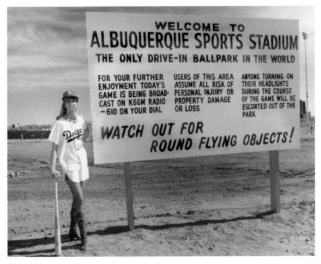

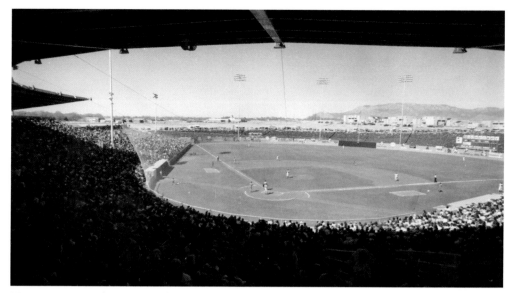

Here are two similar interior shots of the Albuquerque Sports Stadium before the land beyond the left-field fence and drive-in area were built up. For a while, the area just beyond the drive-in area in dead-center field was jokingly called "Freebie Hill," because people gathering out there got a clear view of the action in the ballpark. Nobody ever complained about the view afforded the bulk of the grandstand, as most spectators could watch the Sandia Mountains in the distance to the east appear pink and even purple as the sun began its descent. The same view is available at Isotopes Park, opened in 2003, although fewer fans can see the mountains now. (Both Dick Moots collection.)

A FORCE IN THE TEXAS LEAGUE

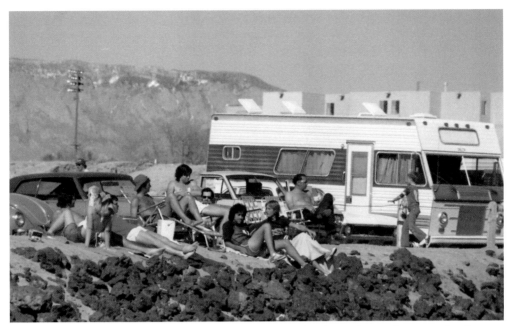

The photograph above shows how fans could really make themselves at home in the drive-in area at the Albuquerque Sports Stadium, watching the game from the front seat of their car or RV or relaxing on chaise lounges. During some Fourth of July ballgames, some fans got a little carried away, and on at least one occasion a game had to be stopped after fireworks were shot at the outfielders. Fans seated behind the screen (below) could get pretty close to the action without much worry of getting hit by a foul ball. The open-air press box can be seen at the top of the stands; in the 1990s, the addition of plastic windows afforded the media some protection from the wind and cold, and a bathroom was built up there. (Both Dick Moots collection.)

The cover on the 1969 program was reminiscent of the old "bum" made famous in the Dodgers' days in Brooklyn. The new $1.4-million ballpark opened with a preseason game between the Cleveland Indians and the San Francisco Giants. A crowd of 13,767 showed up to see the game, when leadoff batter Willie Mays led off with a groundout. Box seats at Albuquerque Sports Stadium went for $1.75 in 1969.

A FORCE IN THE TEXAS LEAGUE

A SPLASH IN THE PACIFIC

(COAST LEAGUE)

When the Dodgers left Ebbets Field in Brooklyn for California in 1958, it made sense to have their Triple-A club closer than Montreal, where the Royals won the International League crown in 1958 in their final season. In February 1957, Dodgers' owner Walter O'Malley agreed to buy the Los Angeles Angels and their stadium, Wrigley Field. Later that year, PCL directors rearranged the league and moved the Los Angeles franchise to Spokane, where the Dodgers' top farm team remained, winning PCL crowns in 1960 and 1970. In 1972, the Triple-A Dodgers' affiliate moved south to Albuquerque, bringing a slew of top-notch players who (as soon as 1974) would lead the parent club to the World Series. Albuquerque's fiery new manager, Tom Lasorda, would succeed Walter Alston as manager of the Los Angeles Dodgers and many years later follow Alston through the doors of Cooperstown. Although the team during the Texas League days had been known as the Albuquerque Dodgers, the *Albuquerque Tribune* polled its voters, and they preferred the name "Dukes." Dick Moots of Rio Rancho designed the new conquistador-type logo for the team.

The new Albuquerque Dukes would go on to win the PCL title in their first year. In one of the weirdest occurrences of the 1972 season, knuckleballer Charlie Hough registered two separate relief appearances in a single inning: on July 10, he pitched in relief to the first batter in the eighth inning before being sent by Lasorda to play right field while another hurler pitched to the next batter. After the second batter got out, Lasorda called Hough back in to the mound to pitch to the third batter; Charlie struck him out to end the inning.

From 1980 to 1982, the Dukes won consecutive titles under manager Del Crandall, and they earned titles again in 1987 (manager Terry Collins), 1990 (manager Kevin Kennedy), and 1994 (manager Rick Dempsey). During these years, the Dodgers groomed their top prospects in Albuquerque. From 1992 to 1996, four of the National League's five Rookies of the Year (Eric Karros, Mike Piazza, Raul Mondesi, and Todd Hollandsworth) were former Dodger farmhands who had spent time in Albuquerque. Fans during the Dukes era also saw two Minor League Players of the Year, Mike Marshall (1981) and Paul Konerko (1997), as well as future major-league stars Orel Hershiser, Dave Stewart, Pedro Guerrero, brothers Ramon and Pedro Martinez, Tom Paciorek, and three-fourths of the Dodgers' record-setting infield in Davey Lopes, Ron Cey, and Steve Garvey.

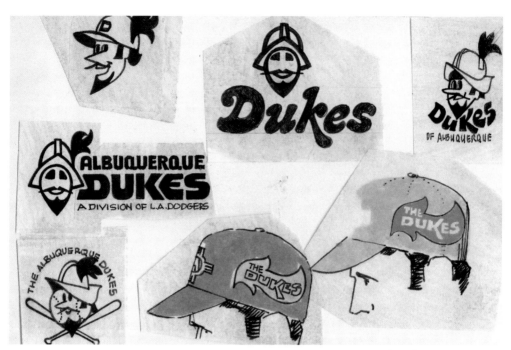

Asked to design a logo for the team, Rio Rancho graphic artist Dick Moots came up with these sketches (above) for general manager Charlie Blaney. Moots also did a lot of work on the team's programs and schedules, as well as promotional spots run on local TV. The design below is the one that Blaney chose—one that people seemingly loved right away and still do almost 40 years later. A human being was even found to mimic the look of the conquistador: Leroi Otero, who donned a costume and helmet and strolled around the ballpark entertaining the fans. (Both Dick Moots collection.)

A SPLASH IN THE PACIFIC (COAST LEAGUE)

This is the PCL schedule for the Albuquerque Dukes in their inaugural season of 1972. As evidenced here, a preseason game between the parent club, the Dodgers, and the Chicago Cubs was played on March 30. It was a great season for the Dukes, who won the PCL championship for manager Tom Lasorda, who subsequently left for Los Angeles to be a coach under manager Walt Alston. (Dick Moots collection.)

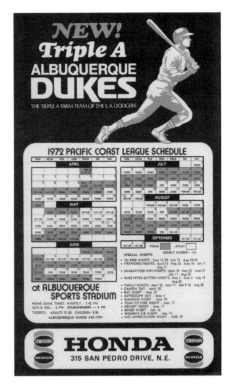

Dick Moots displays a bumper sticker he designed for the 1976 American bicentennial season. It was red, white, and blue, and some can still be seen around town. In 2010, Moots was still living in the same home when he did artwork for the Albuquerque Dukes in the 1970s. He also did some artwork for Texas League teams in Amarillo and El Paso.

Dick Moots was still laughing in 2010 about this promotion—or, rather, the Dukes' "No Promotion Night." Promotions were—and still are—a great way to lure fans to the ballpark. In 1972, the Dukes' front office conjured up a number of popular gimmicks and themes, including five 10¢ beer nights, five fireworks nights, five "Guaranteed Win" nights, and even a "Women's Lib Night," to mention a few. (Dick Moots collection.)

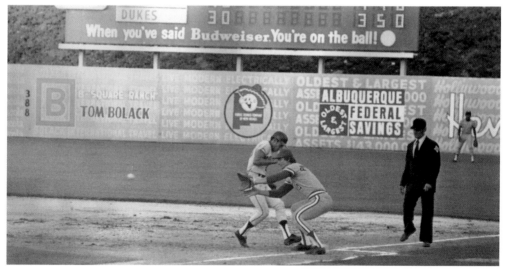

Dukes' first baseman Tom Paciorek awaits a pickoff throw in 1972 during his only season with the team—but what a season it was. Paciorek was named the league's MVP and led the PCL with 27 homers, 186 hits, and 125 runs scored. He went on to have a stellar career in the big leagues and later was the color commentator for the Chicago White Sox on WGN-TV. (Dick Moots collection.)

A SPLASH IN THE PACIFIC (COAST LEAGUE)

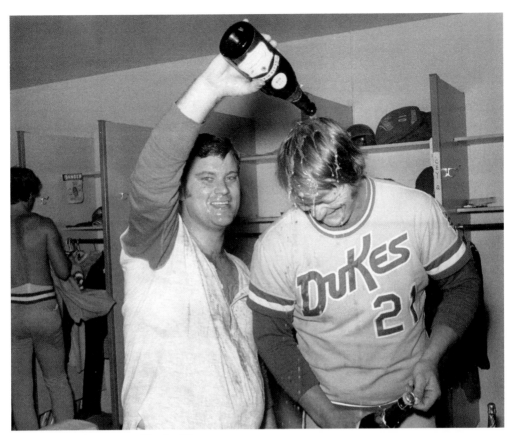

Dukes' general manager Charlie Blaney pours some bubbly over the head of coach George Mott moments after Albuquerque's victory in the 1972 PCL Championship Series. This championship sent the Dukes off to Honolulu for the Kodak World Classic, where they fell to the Caribbean All-Stars 6-2 in 12 innings in the series finale. Teams from Hawaii, Evansville, and Tidewater also played in that short-lived series. (Courtesy of Charlie Blaney.)

Stan Wasiak managed the Albuquerque Dukes for four seasons (1973–1976). His teams chalked up a 275-299 record, with but one winning season: 1974, when the team went 76-66. Wasiak was a baseball lifer, bouncing around the minors from 1940 to 1959, and was a player-manager from 1950 to 1955. In 1972, he was the Dodgers' Double-A skipper in El Paso; when Tom Lasorda was promoted to Los Angeles, Wasiak succeeded him at Albuquerque. (Dick Moots collection.)

A New York native, Terry McDermott was an Albuquerque Duke from 1973 to 1976 after a nine-game, 23-at-bat "cup of coffee" with the Dodgers in 1972. After "Mac" retired, he stayed in Albuquerque to raise his family, working as a sports anchor on a local TV station before a stint in public relations. McDermott is a member of the Albuquerque Professional Baseball Hall of Fame selection committee. (Dick Moots collection.)

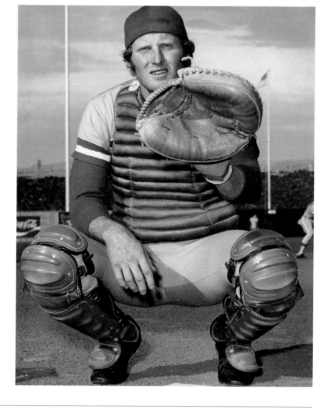

Kevin Pasley wears the "tools of ignorance." A native of the Bronx, Pasley was with the Dukes from 1974 to 1977 and was the opening-day catcher for each of those seasons. He earned promotions to the Dodgers in 1974, 1976, and 1977. In September 1977, the Dodgers sold him to Seattle, where he played through 1978. (Dick Moots collection.)

A SPLASH IN THE PACIFIC (COAST LEAGUE)

Albuquerque outfielder Joe Simpson awaits his turn in the on-deck circle. A member of the Dukes from 1973 to 1978—with a few big-league stints mixed in—this great center fielder is the Dukes' franchise leader in hits (607), triples (35), and at-bats (1,994), and is second only to Brian Traxler in games played (521). Simpson was inducted into the Albuquerque Professional Baseball Hall of Fame in 2010. (Dick Moots collection.)

Future Philadelphia Phillies manager Charlie Manuel clubbed a team-high 30 home runs for the Dukes in 1974 and beat Mickey Mantle in a home-run derby staged at the stadium on June 18, 1974. Manuel's homer production dropped to 16 in 1975, but he spent time with the Dodgers, getting into 15 games. (Dick Moots collection.)

Eddie "The King" Solomon (1972–1975), seen at left, and Rick Rhoden (1972–1974), below, were solid right-handed workhorse pitchers for the Dukes in the team's first few seasons in the PCL. Rhoden went on to have a 16-year career in the big leagues (Dodgers, Pirates, Yankees, and Astros), compiling a record of 151-125 before proving to be a decent professional golfer as a senior. Solomon pitched to a 36-42 lifetime record over 10 National League campaigns (Dodgers, Cubs, Cardinals, Braves, and Pirates) before finishing with six games as a member of the White Sox in 1982. Four years later, he died in an automobile accident in Macon, Georgia, 28 days before his 35th birthday. (Both Dick Moots collection.)

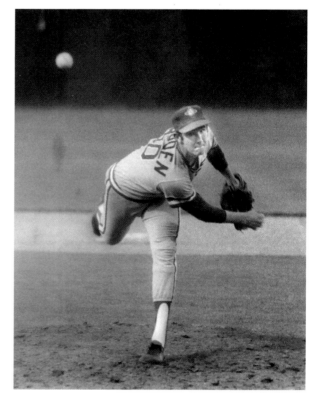

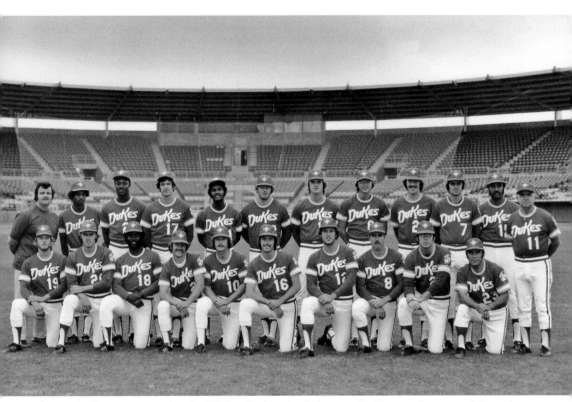

The 1975 Albuquerque Dukes (71-73) finished in third place in the Eastern Division of the eight-team PCL but were memorable for the players who went on to play in the majors. The list of former big-leaguers included Ivan De Jesus, Bobby Randall, Jerry Royster, Joe Simpson, Dennis Lewallyn, Eddie Solomon, Stan Wall, Charlie Manuel, and Greg Shanahan. Shanahan made 29 starts, pitched in 203 innings (a club record), and led the PCL with 147 strikeouts. Royster was the PCL batting champ with a .339 average, and both Terry Collins and Manuel (who drove in seven runs in a game on July 19) went on to become big-league managers. (Dick Moots collection.)

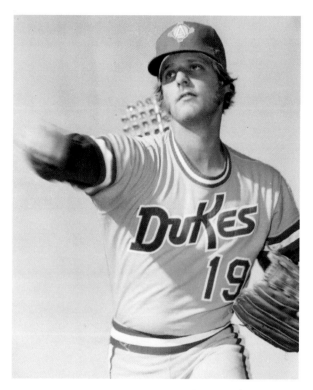

Rex Hudson pitched for the Dukes for four seasons (1974–1977), including three games in which he fanned at least a dozen batters. Despite all of his success with the Dukes, he only had a sip of coffee in the big leagues: two innings in one game with the Dodgers in 1974. Durable on the mound, Hudson made 30 starts in 1975 and had 11 complete games in 1974 and again in 1975. (Dick Moots collection.)

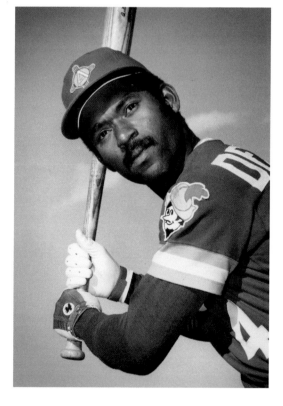

Ivan De Jesus played three seasons (1974–1976) with the Dukes before going on to play 1,371 games in a 15-year big-league career. De Jesus was still in the majors in 2010, coaching first base for the Chicago Cubs, for whom he had played from 1977 to 1981. His son, Ivan De Jesus Jr., arrived in Albuquerque in 2010 to display his own considerable skills at the keystone positions as a member of the Isotopes. (Dick Moots collection.)

A SPLASH IN THE PACIFIC (COAST LEAGUE)

Dennis Lewallyn pitched in six seasons (1975–1980) with the Albuquerque Dukes, so it is no surprise that nobody appeared in more PCL games for the Dukes than Lewallyn (232). He also led the franchise in career complete games (37), victories (74), shutouts (7), and saves (51). The right-hander, voted the PCL MVP in 1980, was inducted into the Albuquerque Professional Baseball Hall of Fame in 2009. (Dick Moots collection.)

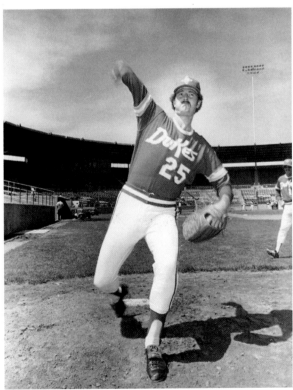

Larry Corrigan (1976–1978), a right-handed pitcher, showed great promise even before he was signed by the Dodgers, pitching in the College World Series while playing at Iowa State University. Corrigan could swing the bat, too, hitting 10 homers for Bakersfield in 1973—the season before he was moved to the mound. He led the team with seven saves in 1977 and concluded his professional career at Triple-A Toledo in 1978, never making it to the majors. (Dick Moots collection.)

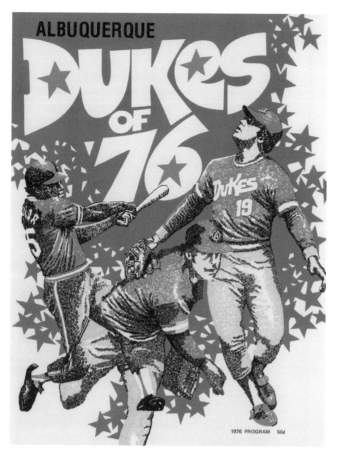

1976 PROGRAM 50¢

This 1976 program cover was printed in patriotic red, white, and blue to honor the American bicentennial, but the season did not turn out very well for the Albuquerque Dukes, who finished in third place again in the Eastern Division. Dennis Lewallyn had a good year, though, with 13 complete games, while Glenn Burke stole 63 bases to lead the PCL. (Dick Moots collection.)

Claude "Big Cat" Westmoreland (1977–1980) showed his versatility by appearing as the opening-day third baseman for the Dukes in 1977, the starting designated hitter in 1978, and the opening-day catcher in 1980. In 1977, Westmoreland homered in seven consecutive games, with nine dingers overall from June 27 to July 3. Thirty-one years later, Albuquerque Isotope Dallas McPherson also homered in seven consecutive games. (Dick Moots collection.)

A SPLASH IN THE PACIFIC (COAST LEAGUE)

Dave Stewart (1977, 1979, and 1980) played a key role in 1980 in the Dukes' first of three straight PCL championships. He made 29 starts, with 11 complete games, a 15-10 record, and a 3.70 ERA. On August 19, 1983, the Dodgers sent Stewart, pitcher Ricky Wright, and $200,000 to the Texas Rangers for Rick Honeycutt. Stewart and Honeycutt later became teammates in Oakland, where the A's went to three straight World Series from 1988 to 1990. (Dick Moots collection.)

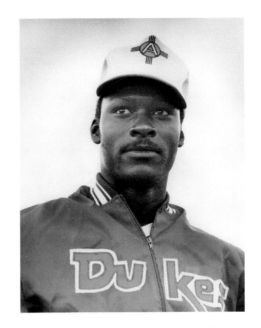

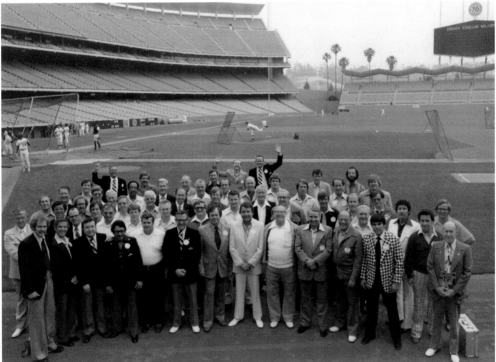

The Dukes of Baseball gather for a group photograph at Dodger Stadium. The Dukes of Baseball was a group of area business people who were not only fans and supporters of the Albuquerque Dukes, but they also worked tirelessly to sell tickets and promote the team. Fred Hultberg, on the selection committee of the Albuquerque Professional Baseball Hall of Fame, was a "Duke," representing the Basket Shop in Old Town. (Dick Moots collection.)

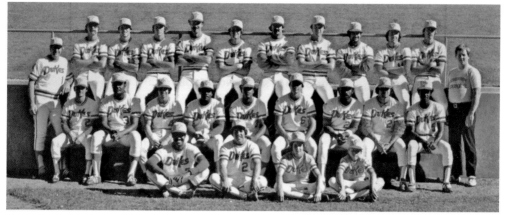

Pictured above are the 1978 Dukes, who did a worst-to-first transformation and finished atop their division, 4.5 games ahead of second-place Salt Lake City. Because the Portland-Tacoma playoff series was postponed due to continuous rains and wet grounds, the Dukes and Tacoma Rainiers were declared co-champions. The team included Ron Washington, Bob Welch, Joe Simpson, Pedro Guerrero, Rafael Landestoy, and Wayne Simpson. They were managed by likeable Del Crandall. The 1979 Dukes, seen below, were also managed by Del Crandall, finished 86-62, and featured quite a few future big-leaguers, including Mike Scioscia, Rudy Law, Dave Stewart, Pedro Guerrero, Mickey Hatcher, Joe Beckwith, and Dennis Lewallyn. One of the batboys, Rod Nichols (front row, second from left), later pitched at the University of New Mexico, made it to the majors, and even pitched in 22 games for the Dukes in 1993. Major-league veteran Vic Davalillo (not pictured) got into 51 games with the team that season at the age of 42.

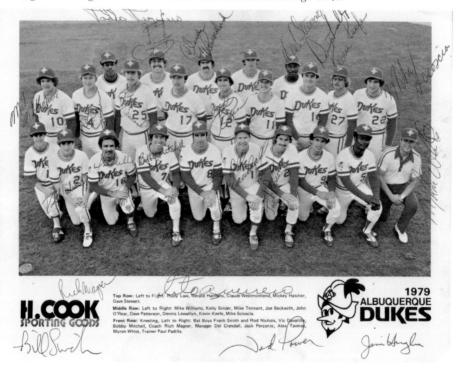

H. COOK SPORTING GOODS

Top Row: Left to Right: Rudy Law, Gerald Hannahs, Claude Westmoreland, Mickey Hatcher, Dave Stewart.

Middle Row: Left to Right: Mike Williams, Kelly Snider, Mike Tennant, Joe Beckwith, John O'Rear, Dave Patterson, Dennis Lewallyn, Kevin Keefe, Mike Scioscia.

Front Row: Kneeling, Left to Right: Bat Boys Frank Smith and Rod Nichols, Vic Davalillo, Bobby Mitchell, Coach Rich Magner, Manager Del Crandall, Jack Perconte, Alex Taveras, Myron White, Trainer Paul Padilla.

1979 ALBUQUERQUE DUKES

A SPLASH IN THE PACIFIC (COAST LEAGUE)

At the 1979 preseason banquet, former Cincinnati Reds' manager Sparky Anderson, (at left—soon to begin managing the Detroit Tigers), and Dukes' manager Del Crandall (right) posed with dinner guests, who later bought the photographs for $5. Between them is the author. The following year, Hall of Famers Joe DiMaggio and Lefty Gomez entertained the gathering with tales from their Yankee days.

Del Crandall, a real gentleman, twice managed in Albuquerque. In 1969 and 1970, he was the skipper for the Double-A Albuquerque Dodgers, with a last-place finish followed by a first-place finish. He led the American League's Milwaukee Brewers from 1972 to 1975. From 1978 to 1983, he managed the Albuquerque Dukes, leaving to manage the Seattle Mariners with 89 games left in their 1983 season. The Dukes won PCL titles for Crandall from 1980 to 1982. (Dick Moots collection.)

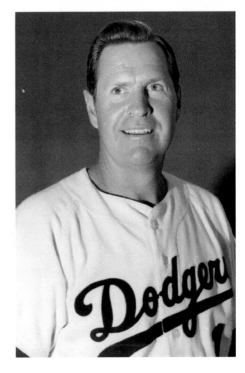

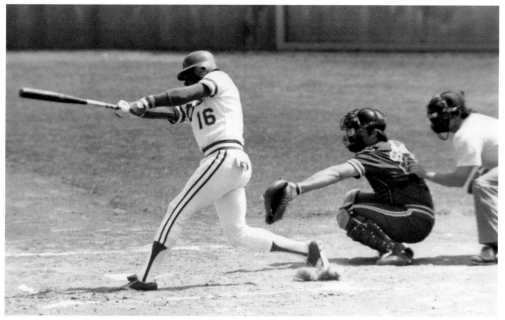

Slugger Pedro "Tito" Guerrero connects with a ball during his days (1977–1979, 1988) with the Dukes. Guerrero led the PCL in RBIs with 118 in 1978 and 103 in 1979, batting a healthy .337 and .333, respectively. He compiled a 31-game hitting streak in 1979 and went on to be a feared slugger in the big leagues with the Dodgers and St. Louis Cardinals. (Dick Moots collection.)

Infielder Ron Washington was a solid third baseman for the Dukes in 1977 and 1978 before going on to play with five big-league clubs: the Dodgers, Twins, Orioles, Indians, and Astros. After spending time with the Oakland A's as a coach, Washington became the manager of the Texas Rangers in 2006, replacing Buck Showalter, and led them to the 2010 World Series. (Dick Moots collection.)

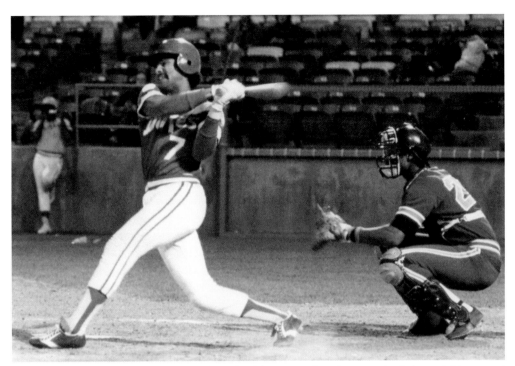

Rafael Landestoy (1976–1978, 1984) takes a healthy cut in this photograph. A dependable second baseman, Landestoy began his big-league career with the Dodgers, and after stops in Houston and Cincinnati he returned to Los Angeles to finish his playing days. Dodgers' catcher Joe Ferguson headed to the Dodgers from Houston after Los Angeles packaged Landestoy and Jeff "Hac Man" Leonard in a July 1978 deal. (Dick Moots collection.)

Given a perfect nickname for a possible future Dodger, first baseman Kelly "Little Duke" Snider (1979 and 1980) even wore the original Duke's no. 4 when he played for the Dukes (the two were related). Although he never made it into the majors, Snider stayed in the Albuquerque area and entered the world of finance after his playing days ended. (Dick Moots collection.)

Two of the best players for the Dukes in the late 1970s were speedy outfielder Rudy Law (1978, 1979, and 1981), at left, and right-hander Rick Sutcliffe (1977 and 1978), below. Both went on to impressive major-league careers. Law, who stole 70 bases to lead the PCL in 1979, wound up in the postseason with the White Sox in 1983, while Sutcliffe, who found himself in Dodger manager Tom Lasorda's doghouse and was traded away, won the Cy Young Award after being dealt to the Chicago Cubs in 1984. Sutcliffe, who won a battle with cancer in 2008, is one of numerous ex-Dukes (and Albuquerque Dodgers) to parlay his baseball knowledge and speaking ability into the broadcast booth—a list that includes Don Sutton, Joe Simpson, Eric Karros, Orel Hershiser, Kevin Kennedy, Candy Maldonado, and Eric Young. (Both Dick Moots collection.)

Mickey Hatcher, at right, and Mike Scioscia, below, were more than just teammates with the Albuquerque Dukes (1979 and 1980) and Los Angeles Dodgers (1980). When Scioscia played for Texas in 1994, Hatcher was a Rangers coach. In 2000, when Scioscia became the Anaheim Angels' manager, he hired Hatcher as part of his coaching staff, and the team went on to win the World Series in 2002. A great backstop during his playing days, Scioscia began his managerial career with the Dukes in 1999. Hatcher was always a good interview and a bit goofy: in one of his old Fleer baseball cards, he holds a baseball glove that is about the size of a small child. (Both Dick Moots collection.)

The photograph at left features New York City–born Vince Cappelli, who played on a University of New Mexico team coached by George Petrol and went on to serve as UNM's head coach from 1977 to 1989 (compiling a 384-350-6 record). He also coached for the Dukes for quite a few years. In the photograph below, Mike Kekich pitches batting practice for the Dukes in the 1990s. Kekich took the mound in six games for the Albuquerque Dodgers in 1966 and pitched 25 more in 1967 after a promotion from Single-A Santa Barbara. After going 2-10 with the Los Angeles Dodgers in 1968, Kekich was dealt to the New York Yankees in December 1968 for outfielder Andy Kosco. Kekich wound up with a 39-51 record in nine big-league seasons and also played in Japan and Mexico. He spent time as an assistant coach for Cappelli at UNM. (At left, Dick Moots collection.)

A SPLASH IN THE PACIFIC (COAST LEAGUE)

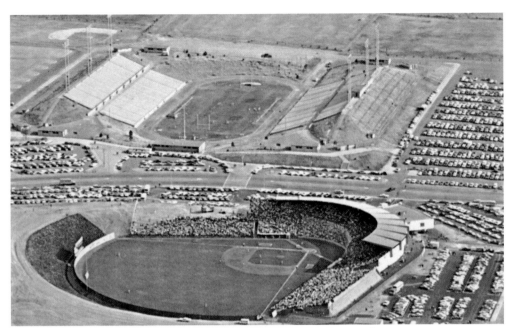

The great aerial view seen above comes from a postcard still occasionally found at local flea markets. It shows University Stadium during a baseball game before several improvement projects and the construction of Albuquerque Sports Stadium. To the left, between the drive-in parking area and the home run fence, is the slope that contained volcanic rock hauled to the ballpark from the extinct volcanoes west of the city. Below is a more recent postcard of the Albuquerque Sports Stadium, seen from almost center field. In the background are the improvements, including a huge press box on the west side of University Stadium, where the UNM Lobos play five or six football games every fall.

Luis Tiant, seen in the photograph at left, was still using his herky-jerky windup when he was a member of the Portland Beavers and pitching at a PCL ballgame in Albuquerque in June 1981. Below is another former AL star, Tiant's Beaver teammate Willie Horton, who was still clinging to hopes that a major-league team would need a designated hitter that year; nobody did.

A SPLASH IN THE PACIFIC (COAST LEAGUE)

Here is the lineup card from the Albuquerque Dukes' dugout wall on June 15, 1981, when the Dukes faced the Portland Beavers and Willie Horton was the Beavers' designated hitter. Vance Law, batting seventh, was also in the Portland lineup; he would go on to regularly visit Albuquerque in the 21st century as the head coach of the Brigham Young Cougars baseball team. On the Dukes' side of the lineup card are some of the familiar names that helped bring the Duke City its second PCL title in a row: Jack Perconte, Bobby Mitchell, Mike Marshall, and Candy Maldonado.

ALBUQUERQUE DUKES
• LINEUP CARD •

DATE 6-15-81

	ALBUQUERQUE DUKES		VISITING CLUB
1	Wilson 7		Beall 3
2	Perconte 4		Mitchell 7
3	Mitchell 8		Torres 8
4	Roenicke DH		Horton DH
5	Marshall 3		Augustine 9
6	Weiss 6		Hilton 5
7	Maldonado 9		Law 4
8	Fobbs 5		Torres 2
9	Richards 2		Smith 6

| LH | EXTRA | RH | LH | EXTRA | RH |

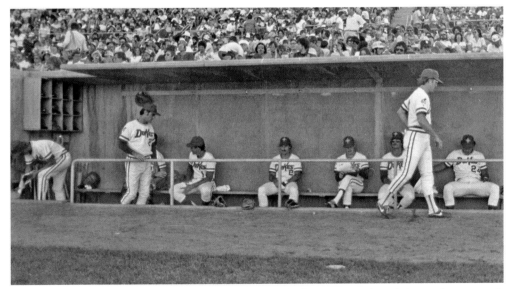

Here is the Albuquerque Dukes' dugout during a 1981 ballgame. Seen from left to right are coach Dick McLaughlin (standing), coach Brent Strom, Jack Perconte, Dave Patterson, Kevin Keefe, Gary Weiss (walking in front of the railing), and Mike Marshall. The Dukes' dugout, like the one for the Isotopes today, was on the third-base side of the field. When the Lobos play at Isotopes Park, coach Ray Birmingham has his team in the first-base dugout.

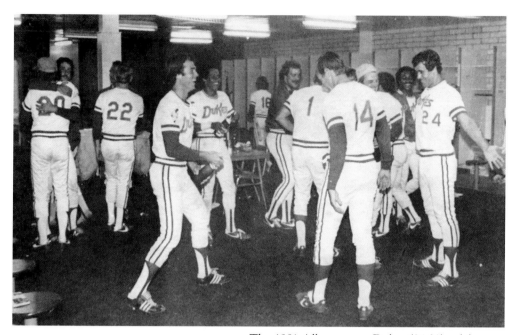

The 1981 Albuquerque Dukes (94-38) celebrate in their clubhouse after sweeping Tacoma in the best-of-five championship series and winning their second-straight PCL title. Minor League Player of the Year and PCL triple-crown winner Mike Marshall (24) is at right. The 1981 title was the Dukes' third PCL championship and the second of three in a row. The 1981 Dukes are widely considered to have been one of the best teams in minor-league history.

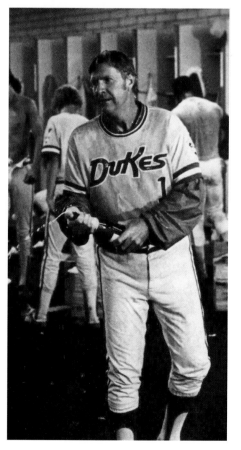

Manager Del Crandall sprays champagne in 1981 to celebrate the Dukes' second PCL title in a row (with another to come in 1982). Though never known as a rabble-rouser, Crandall knew how to celebrate; back in his playing days, he had been in the winning clubhouse after the Milwaukee Braves defeated the New York Yankees in the 1957 World Series.

A SPLASH IN THE PACIFIC (COAST LEAGUE)

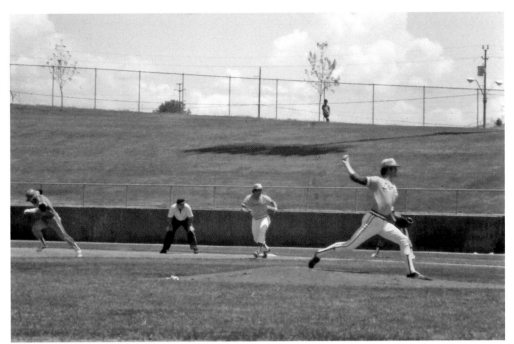

Hurler Brian Holton delivers a pitch in a 1981 game while first baseman Mike Marshall gets into position as an opposing runner heads to second. Holton, with the Dukes from 1981 to 1986 and again in 1991 and 1992, struck out more batters than any other Dukes pitcher in the team's PCL days and started a franchise-high 141 games. His 63 victories in a Dukes uniform are second only to Dennis Lewallyn, who had 74.

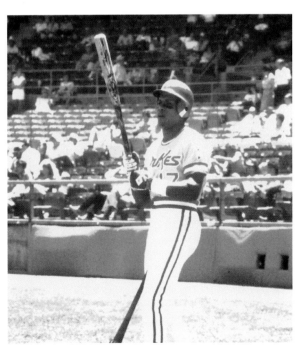

The "Candy Man," outfielder Candy Maldonado, was a key cog in the Dukes' PCL championships in 1981 and 1982. He later went on to play in the big leagues with the Dodgers, Giants, Indians, Brewers, Blue Jays, Cubs, and Rangers in a career that lasted from 1981 to 1998. Maldonado was on World Series winners in 1981 (Dodgers) and 1992 (Blue Jays) and on the losing team in 1989 (Giants).

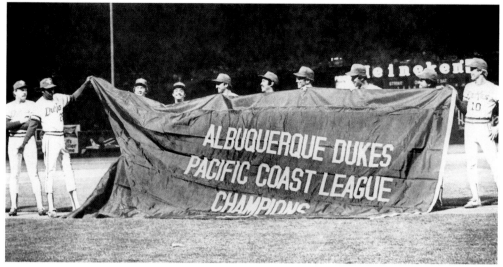

The 1982 Albuquerque Dukes proudly display the championship banner denoting the club's 1981 title. Highlights in 1982 included Sid Fernandez fanning 13 in his PCL debut, Rich Rodas's 14 victories, and Greg Brock clouting three homers in a game as well as leading the PCL with a franchise-record 44 dingers and 138 RBIs.

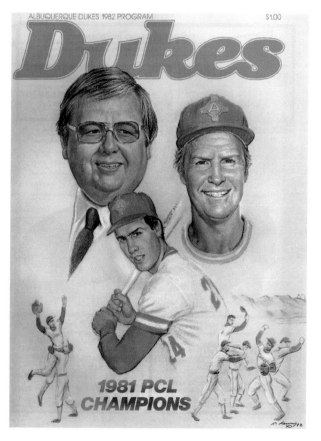

General manager Pat McKernan, manager Del Crandall, and Minor League Player of the Year Mike Marshall adorned the cover of the 1982 Dukes' program, celebrating the team's second PCL title in a row. The 1982 season marked the team's third title in a row. Marshall spent most of the 1982 season in Los Angeles, but McKernan and Crandall were still around to see the team continue its success.

A SPLASH IN THE PACIFIC (COAST LEAGUE)

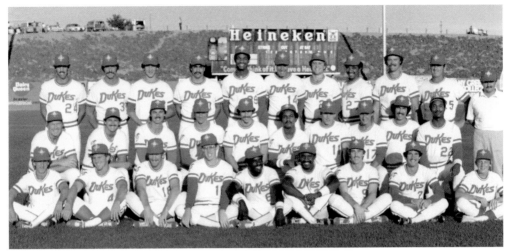

The 1982 team was managed by Del Crandall (middle row, far left). Bespectacled Orel Hershiser is in the front row, while future big-league manager and TV broadcaster Kevin Kennedy (second from left, back row) is in the back row to the far left. The Dukes won their third PCL crown in as many years. Brian Holton (fourth from right, back row) was the opening-day pitcher, and Mike Marshall was the designated hitter.

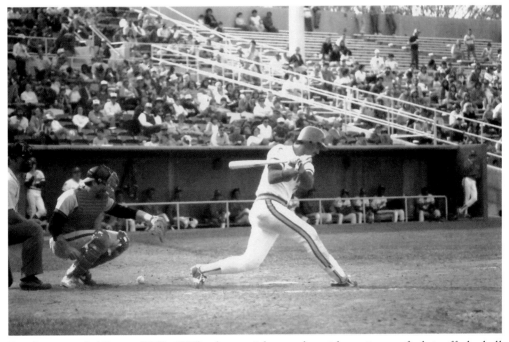

First baseman Sid Bream (1982–1985) takes a mighty cut but either misses or fouls it off; the ball is visible in front of the catcher. Bream is remembered by many baseball fans, especially those in Atlanta, for scoring the winning run in the Braves' NL Championship Series victory over Pittsburgh in 1992, when the slow-footed Bream scored ahead of Barry Bonds's throw to the plate.

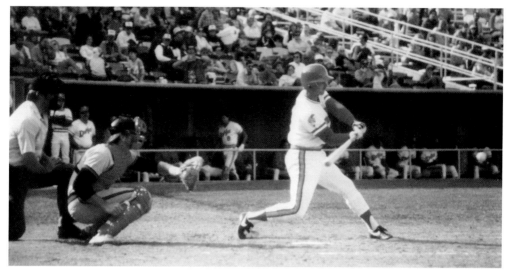

Seen here is the "lesser" of the Sax brothers, Dave Sax (1982–1984), who was a catcher. His second-baseman brother Steve bypassed the Dukes, going from Double-A San Antonio to the Los Angeles Dodgers in 1981 and playing for 14 seasons. Dave, who batted .343 for Albuquerque in 1983, played in 37 big-league games in a five-year career (1982 and 1983 with the Dodgers and 1985–1987 with the Red Sox).

Southpaw Sid Fernandez had a remarkable debut with the Dukes, striking out 13 Phoenix Firebirds in just six innings on June 13, 1982, at Albuquerque Sports Stadium. Fernandez soon found himself with the Dodgers, who traded him to the Mets in December 1983 for Bob Bailor and pitcher Carlos Diaz. Diaz then went 7-3 for the rest of his career. "El Sid" went 114-95 over the next 14 seasons.

A SPLASH IN THE PACIFIC (COAST LEAGUE)

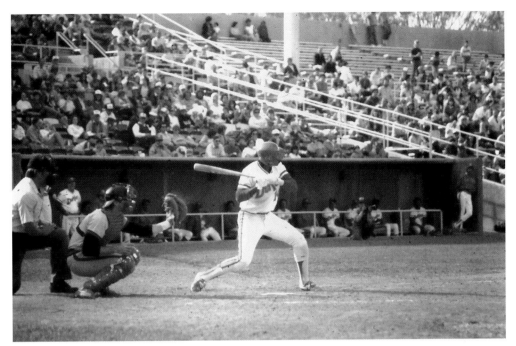

German Rivera (1983–1985) showed signs of stardom in 1983 when he swatted 24 home runs, batted .328, drove in 103 runs, and helped get the Dukes to their sixth-straight postseason berth. When Rivera and pitcher Rafael Montalvo were dealt to Houston for Enos Cabell, the Astros' Triple-A team happened to be in Albuquerque, so Rivera and Montalvo simply moved their gear to the visitors' clubhouse.

Terry Collins played for the Albuquerque Dukes from 1975 to 1978 before becoming a coach for manager Del Crandall in the PCL championship year of 1980. When Crandall left the Dukes to assume the reins of the Seattle Mariners in mid-1983, "T. C." became the Dukes' manager, and he remained in that position through 1988, winning the PCL crown in 1987. Collins managed in the bigs with Houston (1994–1996) and Anaheim (1997–1999). (Dick Moots collection.)

Although he turned out to be a great starting pitcher in his time in the majors, right-hander Orel Hershiser (left) started his professional career as a reliever. Here he and infielder Ross Jones are all smiles after the Dukes won their 1983 opener, with Hershiser picking up a save.

Infielder Dave Anderson (1982, 1983, and 1992), at left, and outfielder Tack Wilson (1980–1982) chat before batting during a 1982 ballgame. The two had a great 1982 for manager Del Crandall: Wilson won the PCL batting title with a .378 average and Anderson finished fifth at .343. It was a different story in the majors, though, as Wilson played in just 12 games, while Anderson played in 873 games over a 10-year career.

Infielder Jeff Hamilton (1986, 1987, 1991, and 1992), seen at right, and pitcher Balvino Galvez (1986, 1992), below, were among the Albuquerque Dukes featured in postcard-sized baseball cards issued in 1986. Hamilton, whose career was shortened by back trouble, played from 1986 to 1991 with the Dodgers, while Galvez was 0-1 in 10 games for the 1986 Dodgers and concluded his professional career in Japan. His son, Brian Cavazos-Galvez, was a local standout at Manzano High School and was named the Louisville Slugger Player of the Year in his senior season. He then played for the UNM Lobos. Cavazos-Galvez was selected by the Dodgers in the 12th round of the 2009 draft and was a Pioneer League All-Star and MVP after batting .322 with 18 homers and 63 RBIs for Ogden. (Both TCMA Ltd.)

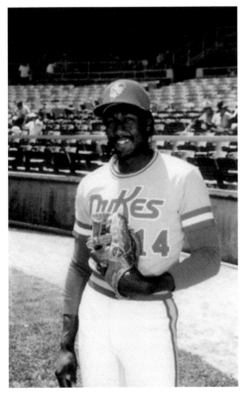

Not many right-handers were better than Orel Hershiser. He first pitched for the Dukes in 1982 and recorded 16 saves and 10 wins for the team in 1983. Hershiser returned to Albuquerque in 1991 for a Triple-A start after missing most of 1990 due to reconstructive surgery on his right shoulder.

Former big-league pitcher Brent Strom was the Dukes' pitching coach in 1983 when he posed for this photograph with Bob "Sportsmith" Smith, who had trouble remembering people's names yet served as the team's public-address announcer. Sadly and strangely, Smith took his own life a few days before the 1984 season began.

This shot was taken from the left-field grandstand of a night game in the 1970s; a smaller-than-average crowd is on hand. In the 1990s, a gazebo was built on the berm beyond the seats along the first-base side of the grandstand, and groups could enjoy picnics there before ballgames. (Dick Moots collection.)

Albuquerque Dukes' third baseman Dave Hansen (1989–1991) and catcher Darrin Fletcher (1989 and 1990) were all-stars in 1990. This photograph was taken at Cashman Field in Las Vegas, Nevada, where the annual Triple-A All-Star Game was played. Dukes' manager Kevin Kennedy was the NL affiliates' manager for the ballgame. Hansen enjoyed a 15-year career in the bigs; Fletcher played there for 14.

Leroi Otero - "Lee The Duke"

Here is an excellent caricature of the team's mascot, Leroi "Lee the Duke" Otero. A fan favorite for nearly two decades, Otero entertained young fans by juggling and making coins disappear. This was the cover on a coloring book in 1989, which featured sage advice from Dukes players. Lee the Duke was succeeded by a large, furry mascot, "Orbit," who arrived at Isotopes Park in that team's inaugural season of 2003.

Kirk Gibson, star of the 1984 Detroit Tigers' World Series championship and the Dodger whose homer off Dennis Eckersley in Game 1 of the 1988 World Series will never be forgotten, warms up before a 1990 game at Albuquerque Sports Stadium. This was Gibson's final season with the Dodgers, but he went on to play with Kansas City in 1991 and Pittsburgh in 1992. In 2010, he was named manager of the Arizona Diamondbacks.

A SPLASH IN THE PACIFIC (COAST LEAGUE)

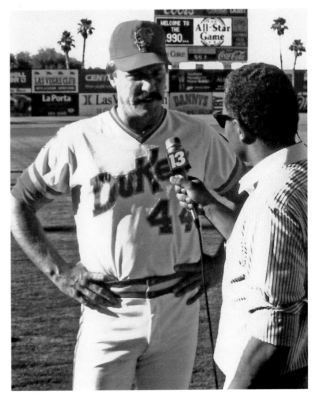

Above, Dukes teammates Michael Huff (1988–1990), left, and shortstop Jose Offerman (1989–1991, 1994) chat in the dugout in Las Vegas before the 1990 Triple-A All-Star Game. Offerman was widely heralded when he came to the Dukes, while Huff was a blue collar–type player. In 1990, Huff batted .325 and scored 99 runs, while Offerman led the PCL in steals with 60 and was named the league MVP. Dukes' manager Kevin Kennedy (1989–1991) played for Albuquerque in 1982 and 1983 and then guided the Dukes to the PCL Championship in 1990. At right, he is being interviewed at Cashman Field in Las Vegas, where he was the manager for the National Leaguers in the Triple-A All-Star Game.

In the photograph at left, Mike Piazza, a 62nd-round draft pick of the Dodgers in 1988, warms up before a 1992 game at Albuquerque Sports Stadium. A likely candidate for the Baseball Hall of Fame, that year Piazza batted .341, clouted 16 home runs, and drove in 69 runs while playing in just 94 games after a promotion from Double-A San Antonio. His numbers earned him a promotion to the Los Angeles Dodgers, where his godfather, Tom Lasorda, was the manager. Seen below is right-hander Pedro Martinez (1991–1993), a regular autograph signer before ballgames at Albuquerque Sports Stadium. He was the middle brother of three Martinez brothers who pitched for the Dukes: Ramon (1988 and 1989) and Jesus (1995 and 1997) were the others. Pedro was dealt to Montreal for Delino DeShields after the 1993 season and went on to win 55 games for the Expos over the next four years.

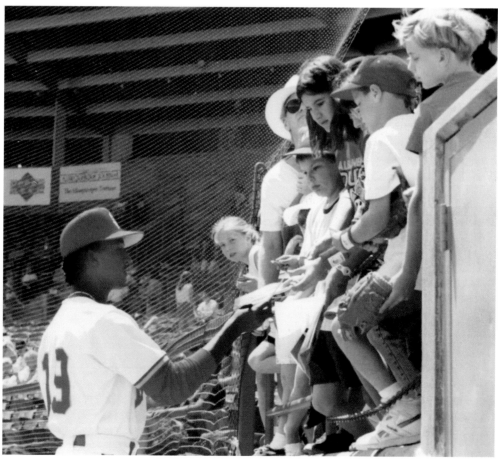

A SPLASH IN THE PACIFIC (COAST LEAGUE)

From left to right, Billy Ashley (1992–1994, 1996), Mike Busch (1993–1996), and Jerry Brooks (1991–1994) warm up before a game at Albuquerque Sports Stadium. In 1993, Ashley hit 26 homers and led the PCL with 100 RBIs, Busch hit 22 homers and had 70 RBIs, and Brooks was fourth in the PCL batting race at .344. Todd Williams led the PCL with 65 appearances and 21 saves. Bill Russell was the team's manager.

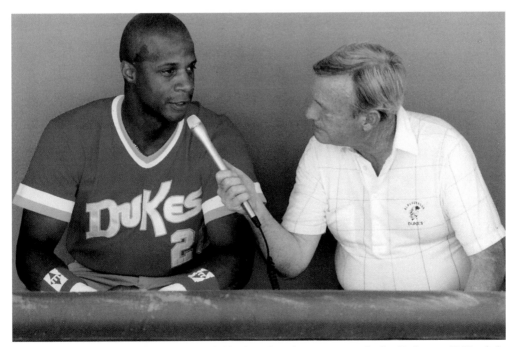

Big-league slugger Darryl Strawberry (left) played in five games with the Dukes in 1993 while on a rehab assignment with the Dodgers. Here longtime broadcast Mike Roberts interviews him in the Dukes' dugout before a game. Strawberry had been forecast early in his career as a Hall of Famer but fell short of expectations; Roberts was inducted into the Albuquerque Professional Baseball Hall of Fame in 2010.

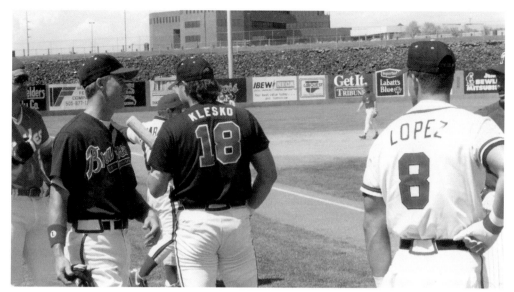

The Albuquerque Sports Stadium played host to the 1993 Triple-A All-Star Game and, after going three months without a rain delay of any kind, the ballpark experienced a steady downpour that resulted in the game not getting underway until two hours after it was scheduled. Above, Richmond's Chipper Jones (second from left) walks past teammate Ryan Klesko as another Richmond player, catcher Javy Lopez, glances over. In the photograph below, the dugout of the National League affiliates is lined with all-stars as they watch their American League counterparts take fielding practice before the game. A crowd of 10,541 was on hand to see the NL team, which included several Dukes including slugging outfielder Billy Ashley, throttle the AL team 14-3. Former Duke Charlie Manuel was the AL team's manager.

A SPLASH IN THE PACIFIC (COAST LEAGUE)

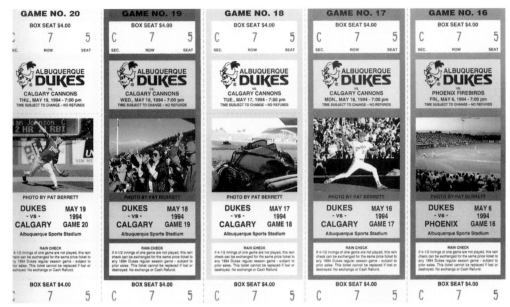

Pat Berrett was the official photographer for the Albuquerque Dukes in the 1990s, and his images appeared on the tickets during the 1994 season, making them fine collectibles to this day. Eric Karros and Mike Piazza, winners of the National League Rookie of the Year awards in 1992 and 1993, respectively, were on some of the tickets in a similar series released in 1996.

Brian Traxler (1989–1993, 1995) won the admiration of Albuquerque Dukes fans' hearts, probably because he looked like the chubby kid next door but could hit and field with the best of them. The all-time leader in games played (544) with the Dukes, Traxler appeared in nine games and had 11 at-bats with the Dodgers in 1990. He passed away in November 2004 at the age of 37.

Paul Konerko (1996–1998) was drafted as a catcher but played the infield corner positions until the Dodgers decided first base was his best position. He was the PCL's MVP in 1997 after batting .323 with 127 RBIs and 37 homers. The Dodgers dealt him to Cincinnati on July 4, 1998, and the Reds sent him to the White Sox on Veterans Day that year.

Eddie Murray was released by the Angels on August 14, 1997, and signed by the Dodgers six days later. Los Angeles sent him to Albuquerque to get his stroke back—and Murray socked two homers in nine games with the Dukes. He headed to Los Angeles and appeared in nine games as a pinch-hitter for the Dodgers that year. Murray had previously played for the Dodgers from 1989 to 1991.

5

THE MARLINS ARRIVE

IN ALBUQUERQUE

After two years without baseball (2001 and 2002) when the Dodgers had moved their Triple-A affiliate at Las Vegas, Nevada, and the PCL franchise that had been here was sold to Portland, Oregon, a "new" stadium (technically it was a $25 million renovation project) was ready for occupation on the same spot where Albuquerque Sports Stadium had delighted fans from 1969 to 2000. Isotopes Park became the new home for the Triple-A affiliate of the Florida Marlins in 2003.

People had moved to New Mexico from many parts of the United States, yet very few had come from Florida. The Marlins' former Triple-A affiliate had been in Calgary, Alberta, Canada, an even longer flight than from Albuquerque to Miami for call-ups. Still, rooting for the future Marlins satisfied the die-hard fans for six seasons (2003–2008), and they enjoyed their gorgeous new stadium, the team's zany mascot Orbit, and a few of the players who came through town, among them Jason Wood, Robert Andino, and Valentino Pascucci. The team drew season-attendance figures that ranged between 563,686 to 593,606 (in its final year), and manager Dean Treanor was popular, too, with some of his humorous antics paving the way for an ejection or two.

As it turned out, the Marlins' top prospects were groomed for the big leagues at Double-A Carolina, but those fans who came to games in the Isotopes' inaugural season got to see slugging National League first baseman Adrian Gonzalez, the Marlins' first pick in the 2000 draft. Outfielder John Gall, who played for the Isotopes in 2007 and 2008, played for the 2008 U.S. Olympic team. The Isotopes made the playoffs in 2003 but were eliminated in the first round of the playoffs by Nashville. In the second season, former Albuquerque Dukes' third baseman Tracy Woodson was the team's manager, but he lasted only one season, and Treanor was back from 2005 to 2008.

And how about the nickname, the Isotopes? In an example of life imitating art, it was actually inspired by a 2001 episode of *The Simpsons* in which Homer goes on a hunger strike to protest the planned move of his beloved Springfield Isotopes to Albuquerque.

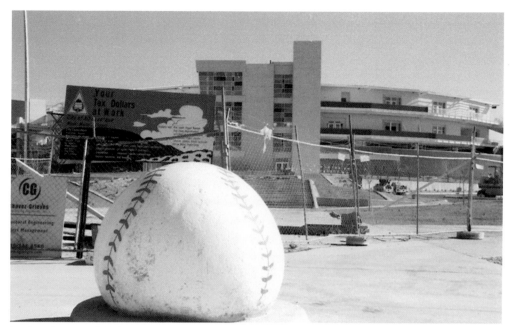

In the photograph below, Isotopes Park takes shape in November 2002. The four-story section is behind home plate, with suites and the press box occupying that space. While the structure was going up on the outside, the infield was being sodded and had one of the best surfaces in the PCL, if not in all the minor leagues, by the time the 2003 season began. In the above photograph is the big concrete baseball that was first "planted" in front of Tingley Field before being transplanted to the front of the Albuquerque Sports Stadium in 1969. Now, 41 years later, it is still a landmark with youngsters scrambling atop the ball to get their photographs taken with the stadium in the background.

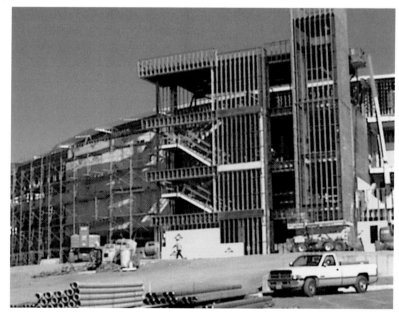

THE MARLINS ARRIVE IN ALBUQUERQUE

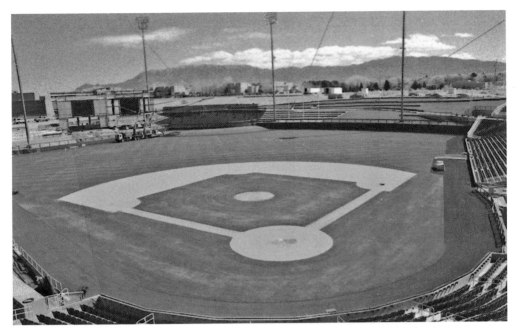

Inside Isotopes Park in the early months of 2003, when the scoreboard and video board were yet to be completed, the "batter's-eye" in dead-center field had yet to be erected, and more plantings were on their way. The bullpens were first located in foul territory but were later moved beyond the left-field wall. Compare this photograph to the ballpark today.

The $25-million renovated stadium opened in time for the 2003 baseball season, and this is what fans found on seats along the aisles—a classy figural. There were 11,054 seats with backrests, a Creamland berm that could fit up to 1,800 fans on the grass, room for 425 in the picnic area beyond the left-field fence, and 30 suites. Isotopes Park has a total seating capacity of 13,279.

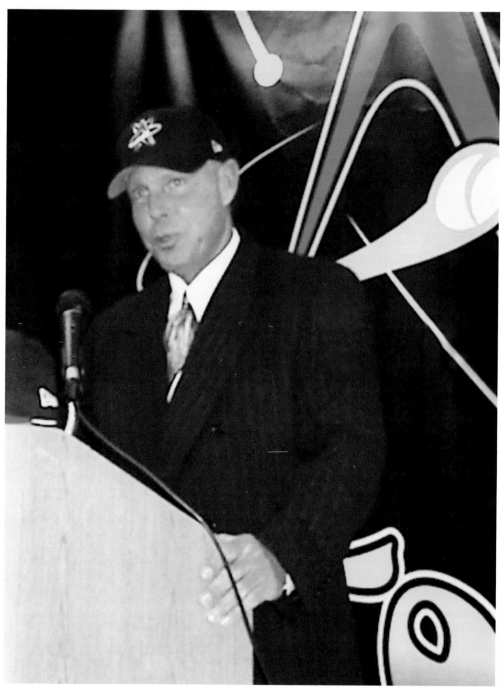

Dean Treanor meets the media after being named the first Isotopes manager in history. Treanor did not need an introduction to everyone; he had been the pitching coach for the Albuquerque Dukes, replacing former Dodger hurler Claude Osteen on May 26, 1999, and remained in that post through the 2000 season for first-year manager Tom Gamboa. Treanor managed the 'Topes in 2003 and again from 2005 to 2008.

THE MARLINS ARRIVE IN ALBUQUERQUE

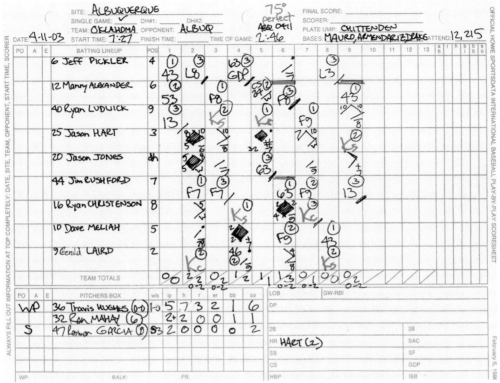

This is the official scorer's score sheet for the Oklahoma RedHawks, the first team to play the Albuquerque Isotopes in their new ballpark on April 11, 2003. Jeff Pickler was the first batter and grounded out, second to first. Jason Hart led the RedHawks, going 3 for 4, and Travis Hughes became the first winning pitcher at Isotopes Park as Oklahoma beat the home team, 5-3.

Here is the official scorecard for the host Albuquerque Isotopes in their debut game on April 11, 2003. Nate Bump started, gave up four runs in five innings, and took the loss. Matt Erickson stroked the first hit in the new ballpark. A crowd of 12,215 turned out to see the city's new gem. Designated hitter Chris Ashby also played for the Albuquerque Dukes in 2000.

Adrian Gonzalez, the first pick in the 2000 draft by the Florida Marlins, was the first star player to spend time on the Isotopes' roster, although his stay turned out to be just 39 games; the Marlins traded him to Texas on July 11, 2003, and the Rangers dealt him to San Diego before the 2006 season. Gonzalez has since become a NL All-Star and fan favorite. His brother Edgar played for the Isotopes in 2006. Adrian joined the Boston Red Sox in 2011.

The Isotopes watch from their dugout in a 2003 game as versatile player Chris Ashby bats. Ashby, who played for the Albuquerque Dukes in 2000, played for the Isotopes off and on from 2003 to 2007, appearing at virtually every position, including pitcher, during that span. His biggest claim to fame was playing the New York Yankees catcher in the Kevin Costner movie *For Love of the Game*.

THE MARLINS ARRIVE IN ALBUQUERQUE

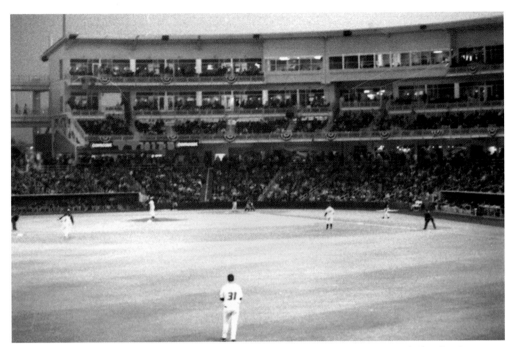

It is an impressive ballpark, to be sure, and many fans visiting Isotopes Park for the first time compare it to a major-league venue. This is a shot of a night game, taken from left-center field. There are plush suites in the center of the uppermost floor on either side of the press box.

Rich Alday (foreground) was the head coach at the University of New Mexico from 1990 to 2007, with his Lobos playing the bulk of their home games at Isotopes Park since the ballpark's debut season of 2003. It is a great recruiting tool for current UNM coach Ray Birmingham, just as it was for Alday, whose teams compiled a record of 515-513-3 in his 18 seasons.

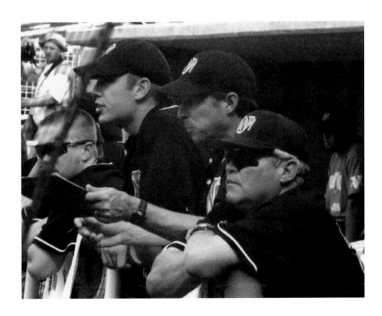

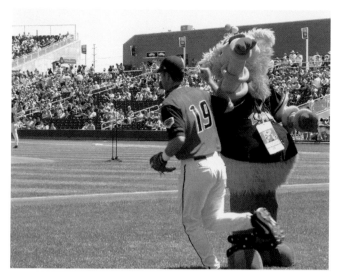

Infielder Jason Wood (no. 19) gets a high-five from Orbit during the 2003 regular-season finale at Isotopes Park. Wood hit .296 that inaugural season and became a fan favorite. He suited up with Isotopes teams from 2003 to 2006 and again in 2008, often playing at third or serving as the designated hitter. In 2003, his first year with the Isotopes, the 33-year-old Wood was one of the team's elder statesmen.

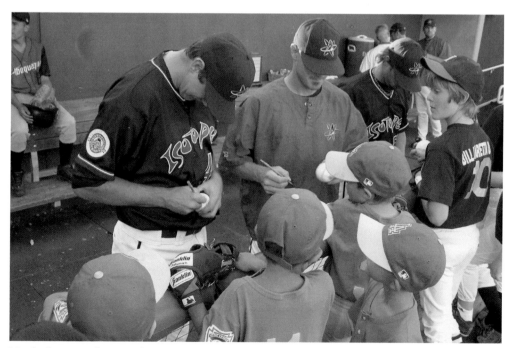

No doubt remembering what it was like to be a Little Leaguer at a "real" baseball game, Isotopes players are generous in their signing habits before a ballgame. The youngsters of the featured Little League teams are introduced, their faces displayed on the huge video board, and they race out to the field with the 'Topes for the playing of the National Anthem before games.

THE MARLINS ARRIVE IN ALBUQUERQUE

Joe Dillon takes some cuts in the cage before a 2004 ballgame. Despite not playing at all in 2003, Dillon led the Isotopes in hits (131), runs (96), doubles (33), and triples (7) in 2004, and he was the team leader in 2004 and 2005 in home runs (30 and 24) and batting average (.325 and .360). He made his big-league debut with a 27-game stint for the Marlins in 2005.

Outfielder Mark Little was with Albuquerque in 2005 and 2006. He had played with five big-league teams and was hoping to get back to the bigs, while most of the other Isotopes were still on their way up the minor-league ladder. Little, for example, had batted a robust .341 in 51 games with the Colorado Rockies in 2001. He hit 14 homers and drove in 52 runs for the 'Topes in 2005.

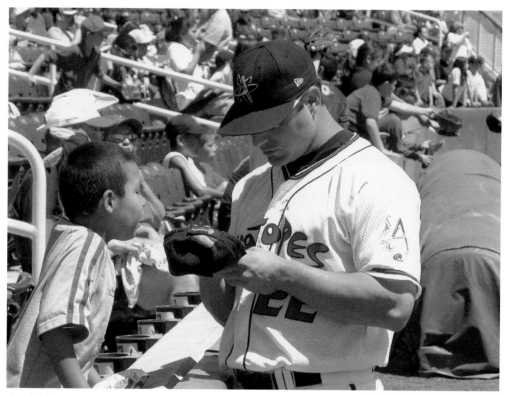

Outfielder Mike Colangelo signs an autograph for a young fan before a ballgame in 2004. Colangelo had played briefly in the majors for three teams before signing a free-agent deal with the Marlins. He hit 16 homers in each of the 2004 and 2005 seasons but hit just seven dingers in 2006, although he batted .318 in 65 games while spending a lot of time on the disabled list.

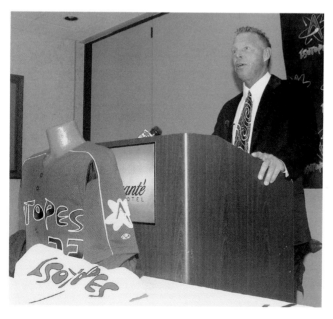

Manager Dean Treanor met with media members at the MCM Elegante, where visiting teams stay while in Albuquerque, to talk about the upcoming 2006 season and show off some new togs. Treanor, who managed the Isotopes in 2003, was the Florida Marlins' minor-league pitching coordinator in 2004 when former Dukes third baseman Tracy Woodson managed the team. Treanor returned in 2005 and remained the skipper through the 2008 campaign.

THE MARLINS ARRIVE IN ALBUQUERQUE

The fans are yelling here during a game at Isotopes Park. Outfielders are pretty good about tossing foul balls to fans, as well as balls that makes the final out in an inning. Isotopes Park fans also scream and wave their arms between innings when park employees stroll around and fire a T-shirt cannon—everyone wants free stuff at the ballpark.

Infielder Robert Andino (2006 and 2007), catching the ball, and outfielder Reggie Abercrombie (2007) warm up before a ballgame on a hot summer day. Andino was a slick-fielding shortstop who led the team in at-bats in both of his seasons and had an Isotopes-record 13 triples in 2007, when he played in all 142 games. Abercrombie used his speed to swipe a franchise-high 41 bases in his lone season with the team.

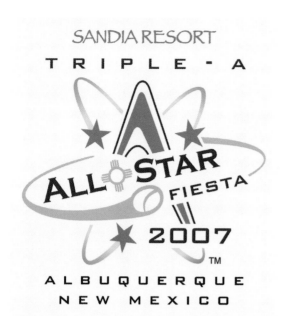

SANDIA RESORT

T R I P L E - A

ALL☆STAR FIESTA

2007
™

A L B U Q U E R Q U E
N E W M E X I C O

This logo was all over Albuquerque in 2007, when Isotopes Park played host to the Triple-A All-Star Game, becoming the first city to host the game twice. Sandia Resort was the site for the all-star luncheon and where the visiting players stayed while in town for the game. On July 11, 2007, the International League beat the PCL 7-5 with 12,367 fans in attendance.

Valentino "The Italian Bazooka" Pascucci played two seasons with the Isotopes (2007, 2009), but he did not expect to be back for that second campaign. He thought he would be with the Los Angeles Dodgers, but they signed big-league veteran Doug Mientkiewicz—who, as it turned out, also ended up in Albuquerque for much of 2009. Pascucci was the first Isotope to have played with the team both when it was associated with the Marlins and when it was an affiliate of the Dodgers.

THE MARLINS ARRIVE IN ALBUQUERQUE

Fireballer Ricky Nolasco began the 2007 season with the parent Florida Marlins, but he incurred some arm trouble early and found himself wearing uniforms for four teams that season: the Marlins, Jupiter of the Single-A Florida State League, Double-A Carolina, and the Triple-A Isotopes. Here he makes his first Isotopes start on August 24, 2004—a 12-5 loss to Memphis. In 2008, he won 15 games with the Marlins.

Seen here before the home finale of the 2007 season are a few of the Isotopes who won various accolades. From left to right, they are Val Pascucci (PNM Power Hitter of the Year), Brett Carroll (Mr. Hustle and Most Community Minded), and Eric Reed (Fan Favorite). Not pictured but also earning honors were Roy Corcoran (Pitcher of the Year), Robert Andino (Best Defensive Player), and Scott Seabol (MVP); Seabol was also the PCL's MVP.

Possibly nobody else in the state loves the game more than University of New Mexico baseball coach Ray Birmingham, seen here chatting with area Little Leaguers during a clinic after his arrival on the UNM campus in 2008. One year earlier, he led New Mexico Junior College team in Hobbs to a runner-up finish at the national tournament, which NMJC won in 2005. Named the Coach of the Year for the UNM Hall of Honor in 2010, the first time the Lobos (38-22) had been in the NCAA postseason since 1962, Birmingham has vowed to lead UNM to even greater national prominence, doing it mostly with kids from New Mexico. Birmingham guided the Lobos to a 34-25 mark in his rookie campaign with the Lobos (2008) before garnering some national attention when UNM won two of three games at no. 1-ranked Texas to start the 2010 season.

THE MARLINS ARRIVE IN ALBUQUERQUE

Through the first seven seasons (2003–2009) of the Albuquerque Isotopes, 269 players had suited up for the team in at least one game. In this photograph, manager Dean Treanor (sixth from the right) talks with his squad in early 2008. By season's end, the team finished in second place, seven games under .500. The next spring, the team was no longer affiliated with the Marlins—the Dodgers were back in town.

The Albuquerque Isotopes are seen running from the left-field foul line out to center field on Media Day in 2008, a few days before their PCL season began. When he was not bothered by his back, third baseman Dallas McPherson was exciting to watch at the plate. The former Angels prospect belted a league-high 42 home runs, which led all of minor-league baseball. Of course, he also struck out a lot.

Right-hander Bobby Keppel, the opening-day starter, tied for the club lead in starts (27) in 2008, when he went 9-11 and had a 5.99 ERA. Keppel, a likeable guy, had worse luck in his major-league debut season of 2006, when he was 0-4 for Kansas City. In 2007, he had an astronomic 11.25 ERA in four games with the Colorado Rockies.

Nobody had a better start to a season than right-hander Daniel Barone, who was 7-0 in 10 starts for the 2007 Isotopes. The seven straight wins tied a franchise record and helped earn him a promotion to the Marlins, where he was 1-3 in 16 games, including six starts. Battling elbow problems in 2008, he came back down to earth, going 1-5 with a 6.61 ERA in nine starts.

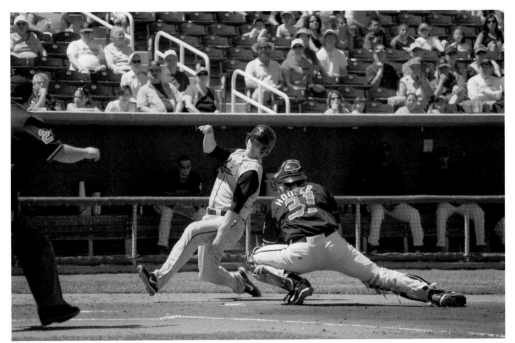

Isotopes catcher Paul Hoover slides to his left to make a swipe tag of an opposing base runner in a 2008 game at Isotopes Park. Hoover played for four seasons (2003, 2006–2008). The 2006 campaign was his best, when he played in 92 games and chipped in with 41 RBIs. Power was never his forte, though, and he never hit more than eight homers in his first 11 seasons as a professional.

The baseball-savvy voice of the Isotopes on 610-AM, the "Sports Animal," since 2006, Robert Portnoy has been moving through the minors just like a player or manager. After two seasons announcing games of the Double-A Huntsville Stars, he moved up to Triple-A Indianapolis in 2005 and then to the Duke City the next year. He also described the action of the Albuquerque Thunderbirds for several seasons.

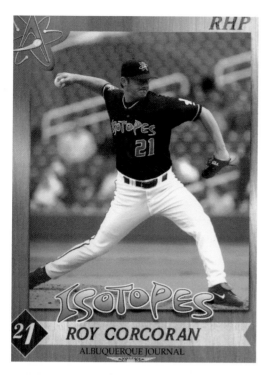

The *Albuquerque Journal* often printed large baseball cards of the Isotopes' players. This 2007 card shows 'Topes pitcher Roy Corcoran, whose brother Tim found himself in the Isotopes' bullpen and pitched in three games in 2008. Tim also got into six games in 2009 (then a Dodgers' farmhand) and was on the roster again in 2010. The two never played together in Albuquerque.

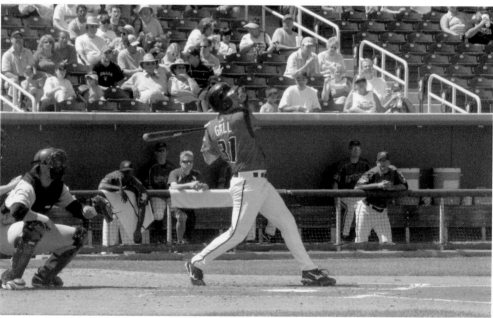

The St. Louis Cardinals' Minor League Player of the Year in 2002, John Gall saw action in only 30 games with the Cards in 2005–2006 before signing with Florida as a free agent in November of 2006. As an Isotope, Gall batted .300 with 13 homers and 58 RBIs in 2007, when he also played in three games for the Marlins. In 2008, he went on to bat .312 with 12 homers and 76 RBIs. That same year, he also played with the U.S. Olympic baseball team.

THE MARLINS ARRIVE IN ALBUQUERQUE

Lined up in front of the Albuquerque Isotopes before a PCL ballgame, these Albuquerque-area Little Leaguers watch as their faces are shown on the video board during their introductions, many of them no doubt dreaming of someday playing on the diamond there. Both the Dukes' and Isotopes' management teams have been very Little League friendly.

Rich Gale (left) was the Isotopes' pitching coach in 2007–2008; he is seen here chatting with assistant general manager Nick LoBue. Gale pitched for four teams in the big leagues and worked with Roger Clemens when he was the Boston Red Sox pitching coach in 1992 and 1993. He took 11 seasons off from the game, returning in 2006 to be the pitching coach at Double-A Carolina.

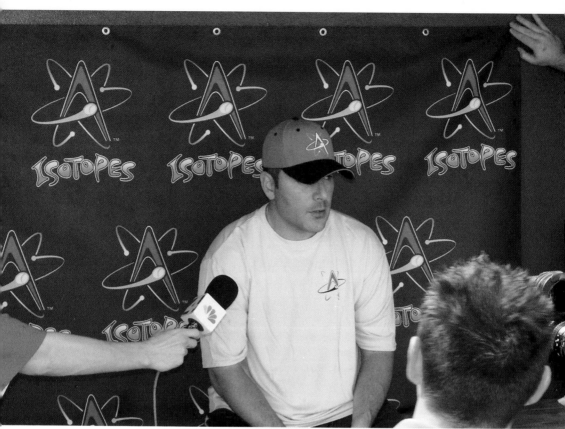

Catcher Paul Lo Duca found himself back in Albuquerque in August of 2008 after being released by the Washington Nationals. Lo Duca, who played with the Albuquerque Dukes from 1998 to 2000, was hoping to return to playing shape and help the Marlins down the stretch. He played in just seven games with the Isotopes, batting .423, before joining the Marlins. After he arrived in the majors to stay in 2000, Lo Duca was a Dodgers' starter from 2001 to 2004, playing in at least 125 games each year, and not only behind the plate but also at first base and the outfield. He was a NL All-Star in 2003 and 2004. In 2001, his first full year in the majors, he had career highs of 25 home runs and 90 RBIs. The Dodgers dealt him to the Marlins just before the trade deadline in 2005. The Marlins dealt him to the Mets in December 2005. At the age of 38, Lo Duca remained in baseball in 2010, this time in the Rockies organization, still hoping to return to the majors.

6

D O D G E R T O W N ,

N E W M E X I C O

Isotopes Park took on a new color, Dodger Blue, shortly after it was announced in September of 2008 that the Los Angeles Dodgers were relocating their Triple-A team in Albuquerque. Fans had missed seeing Dodgers prospects playing in the Duke City and were pleased to trade the Marlins for the Dodgers.

"They came to us, saying, 'We want to come back to Albuquerque,' " said Isotopes' general manager John Traub. "Albuquerque never stopped being a Dodger town. We (were) only going to change (affiliates) if the Dodgers become available." Though the city's pro team had been affiliated with other franchises, too, the Dodgers were the most popular. An all-time record number of fans came out to see their new team play: 601,129 people, which was some 8,500 more than had come out in 2008 for the final season of the Marlins' affiliate that had moved to New Orleans.

Arguably the best-hitting Albuquerque skipper since Duke Snider (1967), Tim Wallach was named the team's manager. The veteran of 17 major-league seasons with the Montreal Expos (1980–1992), Dodgers (1993–1996), and California Angels (1996), Wallach retired in 1996 with 260 career home runs, 2,085 hits, and 1,125 RBI. Wallach did not remember it, but he had actually played one game with the Dukes in 1995 on a short rehab assignment from Los Angeles.

Yet fans don't flock to the ballpark to see the manager flash signals or argue with umpires; it is the players they come to see, and the Dodgers did not disappoint their fan base in Albuquerque. Among the top Isotopes in 2009 were Blake DeWitt, Charlie Haeger, Mitch Jones, Jason Repko, and A. J. Ellis, while former Lobo Scott Strickland was "lights-out" coming out of the bullpen in 2009.

The Isotopes (80-64) made the PCL playoffs for the first time since 2003 but were swept in three games by Memphis. Nonetheless, Wallach had made his Triple-A managerial debut a good one, and he was named the PCL's Manager of the Year.

"The community has been very, very excited that the Dodgers are back in town," Traub said in June 2010. "The Dodgers' impact on us has been very positive. We hope to extend the agreement and get the Dodgers here for an exhibition."

The Albuquerque Isotopes' management brought in former Los Angeles Dodgers manager Tommy Lasorda, also a member of Baseball's Hall of Fame and a great ambassador for the sport, to announce that the Dodgers were sending their Triple-A baseball team back to Albuquerque, which it had left after the 2000 season.

Hall of Fame manager Tom Lasorda and Albuquerque Isotopes' owner Ken Young (right) were on hand in early 2009 when former Golden Spikes winner and former big-league all-star Tim Wallach was named the new manager of the Isotopes. It was Wallach's first stint as a Triple-A manager, but he worked out so well that he was back in 2010, as were his hitting coach John Moses and pitching coach Jim Slaton.

From left to right, Albuquerque Isotopes' manager Tim Wallach, Los Angeles Dodgers' assistant general manager of player development De Jon Watson, and former Dodgers' and Albuquerque Dukes' manager Tommy Lasorda, a special advisor to the chairman, chat briefly before meeting with the media after Wallach was introduced as the Isotopes' manager for 2009.

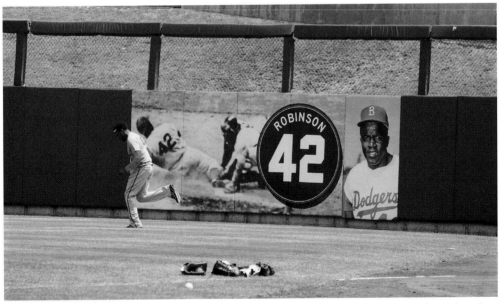

During the 2009 season, the Isotopes honored one of the Brooklyn Dodgers' stars from their first world championship, won in 1955—Jackie Robinson. Robinson broke the major leagues' color barrier in 1947, went on to have a Hall of Fame career, and died in 1972. His legacy has been honored by Major League Baseball's retirement of his number, 42.

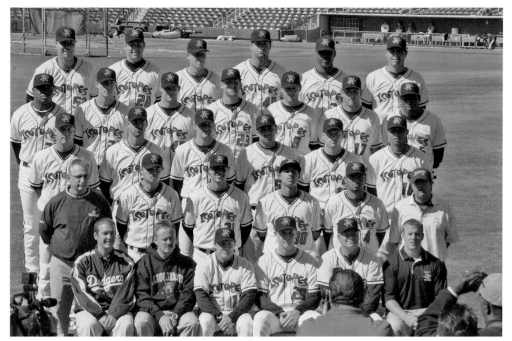

During Media Day in early April 2009, the new Isotopes have gathered for their annual team photograph out in center field. Three of the players knew their way to the site: Juan Castro played for the old Albuquerque Dukes; Valentino Pascucci had played for the Isotopes in 2007, when they were the Marlins' Triple-A affiliate; and Scott Strickland had pitched across the street for the University of New Mexico Lobos.

Hector Luna (no. 5) and his new Albuquerque Isotopes teammates work out on Media Day 2009 at the ballpark. Luna, who had played in the majors since 2004 with the Cardinals, Indians, and Blue Jays, showed that he was not ready to hang them up: his .351 average in 91 games led the 'Topes, and he also hit 17 homers. Luna made 52 starts at third base and filled in at first as needed.

Teammates Jason Repko and Valentino Pascucci watch a spring-training game in Glendale in March 2009, the Dodgers' inaugural season of training in Arizona. Repko played in 110 games for the Isotopes, while Pascucci was released on June 18, eventually finding his way to the Mets organization. In 2010, Repko was with the Minnesota Twins organization.

Veteran major-league hurler Shawn Estes, seen here in a start on a Sunday afternoon—when the Isotopes wear Dodger Blue jerseys—hoped to make a big-league comeback but decided he did not have enough left in the tank and retired on June 18. Before that decision, Estes was 2-1 with a 3.74 ERA in 13 starts, along with a pair of complete games.

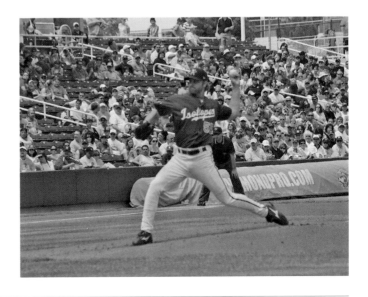

Jamie Hoffmann, arguably the best at fielding baseballs hit to the "Tope Slope" in center field, signs an autograph for a fan on Retro Night on July 17, 2010. That is why Hoffman is wearing an Albuquerque Dukes uniform; during the annual Retro Night, the Isotopes are also listed as the Dukes on the scoreboard, and oldies music from the Dukes' era is played between innings.

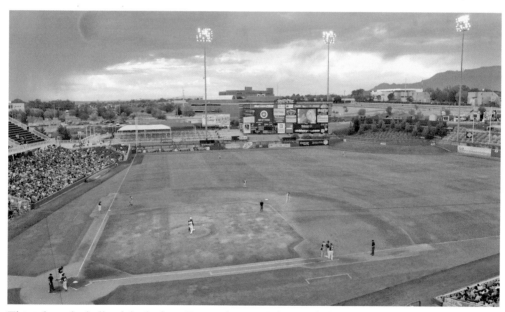

This is how the ballpark looks from Suite 1 during a July 2010 ballgame. Although the temperature was 104 degrees when the first pitch was thrown, New Mexico is known for its dry heat, making things much more bearable than they would be for a 104-degree game in the Midwest or the East Coast. The same great views that spectators had from the old Sports Stadium are still afforded at the new ballpark.

DODGER TOWN, NEW MEXICO

EXTRA INNINGS

First, here is a trio of New Mexico baseball trivia questions (answers below): Who is the only member of baseball's Hall of Fame born in New Mexico? Who are the two current baseball Hall of Famers who played for Albuquerque professional teams in the last 50 years? And, true or false, Willie Mays hit the first-ever homer at Albuquerque Sports Stadium when his San Francisco Giants faced the Cleveland Indians in a 1969 preseason game.

Throughout the years since baseball first arrived in Albuquerque, countless big-time stars have played here. Big-league teams have been stopping in the Duke City for preseason contests for a long time, the first of which may have been in 1936 when Honus Wagner and the Pittsburgh Pirates faced the Philadelphia Phillies. The Dodgers played the Brewers here in 1978, but that was the last appearance of a major-league team in Albuquerque until the Florida Marlins played the Isotopes in 2004. In 2005, the Major League Weekend featured the Colorado Rockies, Texas Rangers, and Arizona Diamondbacks. The most recent event involving the big leagues was the 2010 Major League Weekend, when the Colorado Rockies met the Seattle Mariners for a pair of games, giving fans the opportunity to see likely future Hall of Famers Ken Griffey Jr., Ichiro Suzuki, and Todd Helton.

Add to the mix some Texas League and PCL All-Star Games, the 1993 and 2007 Triple-A All-Star Games, three High School All-American Games, and the 2003 Mountain West Conference Tournament, and fans have seen a lot of great diamond action in the Duke City.

And what are the answers to the questions above? First, Ralph Kiner was born in Santa Rita, New Mexico, and is the only New Mexico–born player enshrined in Cooperstown; Don Sutton (1965) and Eddie Murray (1997) are the Hall of Famers who played on Albuquerque teams (Mike Piazza should soon become the third); and finally, Mays was the first man to bat in a game at the stadium, but the Indians' Tony Horton hit the first homer, so the answer is false.

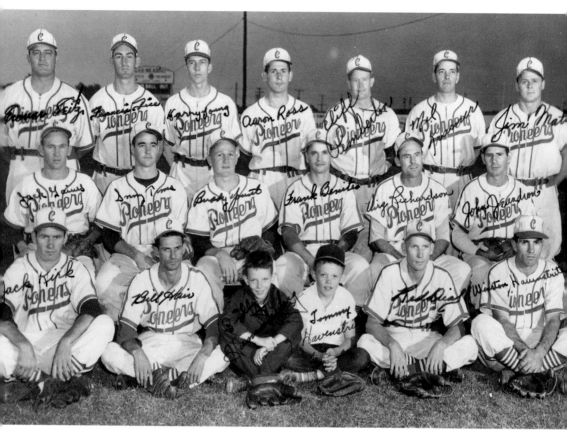

Although Albuquerque has had the most professional baseball teams and the most seasons played in New Mexico, Duke City teams often had other teams from the "Land of Enchantment" facing them, namely in the West Texas-New Mexico League, to which this Clovis Pioneers team belonged in 1952. Other cities with professional baseball at various times were Artesia, Carlsbad, Las Cruces, Hobbs, Raton, and Roswell. Roswell happens to be where future Hall of Famer Willie Stargell played briefly in 1959 and for whom slugger Joe Bauman hit 72 homers in 1954, which was a single-season record for every level of professional baseball until finally broken by Barry Bonds's 73 in 2001. The Rockets were in the Longhorn League in 1954 and thus did not play in Albuquerque; Tingley Field spectators no doubt saw Bauman swat a few "taters" in the 1946 and 1947 West Texas-New Mexico League seasons, however, when he was with Amarillo and clubbed 48 and 38 homers, respectively.

EXTRA INNINGS

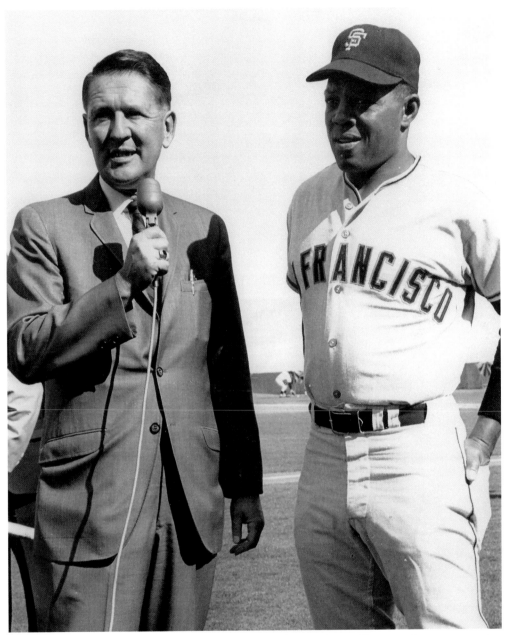

J. D. Kailer (left), the *Albuquerque Journal* sports editor from 1950 to 1959, is seen here interviewing Willie Mays for KOAT-TV at spring training in Phoenix in the 1960s. Kailer also spent time on the airwaves with KDEF-AM. As a youngster, he had the opportunity to see the final three home runs of Babe Ruth's career, on May 25, 1935, when Ruth was playing as a member of the Boston Braves in Pittsburgh. Thirty-four years later, Mays led off the first ballgame played at Albuquerque Sports Stadium. Kailer, a member of the Dukes of Baseball and a longtime fan of UNM sports teams, was inducted into the Albuquerque Professional Baseball Hall of Fame in 2008. (J. D. Kailer.)

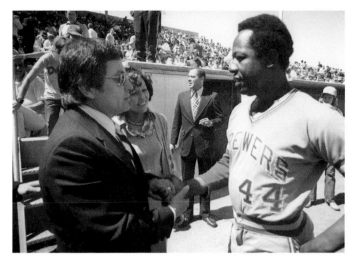

New Mexico governor Jerry Apodaca (left) chats with famed slugger Henry Aaron. Aaron's Milwaukee Brewers played a preseason game against the Chicago Cubs on April 5, 1975. A little less than a year earlier, Aaron had hit his 715th homer (off the Dodgers' Al Downing) to surpass Babe Ruth's previous record of 714. (Dick Moots collection.)

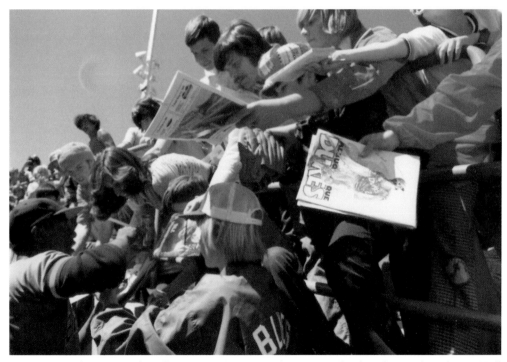

An occasional visitor to the Albuquerque Sports Stadium even after his playing days, future Hall of Famer Henry Aaron is seen obligingly signing autographs before his team's exhibition game against the Cubs in 1975. Aaron was baseball's all-time home-run leader until Barry Bonds passed him in 2007, although some contend that Bonds's record is tainted by his use of performance-enhancing drugs. (Dick Moots collection.)

The scoreboard in left field shows the Chicago Cubs are the visiting team and the Milwaukee Brewers are the home team before a preseason game at the Albuquerque Sports Stadium in April 1975. To the left of the scoreboard and above the fence, fans can be seen sitting in chairs in the drive-in area on a fine spring day, awaiting their day at the ballpark. (Dick Moots collection.)

Former Albuquerque Sports Stadium groundskeeper Richard Arndt was working at Milwaukee County Stadium on July 20, 1976, when he came up with this baseball—which turned out to be the last homer, the 755th, of Aaron's career. For taking the ball, Arndt was fired and had $5 deducted from his final paycheck by the Brewers, who prohibited employees from keeping baseballs. Arndt, who learned groundskeeping in Albuquerque, later moved back to the Duke City and again worked on the field at Albuquerque Sports Stadium before games.

It is a fair argument among baseball fans: who has signed more autographs, Bob Feller (seen warming up at Albuquerque Sports Stadium on one of his many visits) or Pete Rose? Feller has certainly signed more in the Duke City, where Rose has never made his presence known. "Bullet Bob" would pitch to media members before ballgames, pitched at the Mickey Mantle-Charlie Manuel home-run derby in 1974, and merely signed autographs before a game in 1989.

On June 18, 1974, Dukes' slugger Charlie Manuel squared off with New York Yankees' legend Mickey Mantle in a home-run derby at Albuquerque Sports Stadium, with Hall of Fame pitcher Bob Feller and Dukes' catcher Tom Tischinski doing the pitching. Manuel whacked 21 balls over the fence, while Mantle hit but two and told the Dukes' general manager Charlie Blaney that he would never do it again. (Dick Moots Collection.)

EXTRA INNINGS

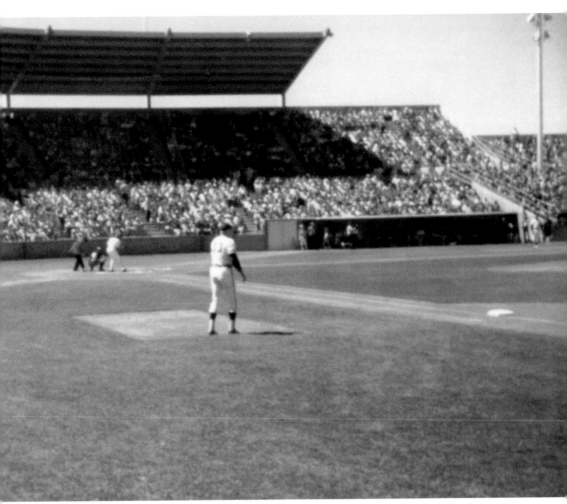

It is hard to believe, but the Los Angeles Dodgers—the parent club of the Triple-A Dukes from 1972 to 2000 and the Isotopes in 2009 and 2010—have not played a preseason game in Albuquerque since 1978, when they faced the Milwaukee Brewers. In this photograph, Frank Howard, the National League Rookie of the Year in 1960, is seen coaching first base for the Brewers.

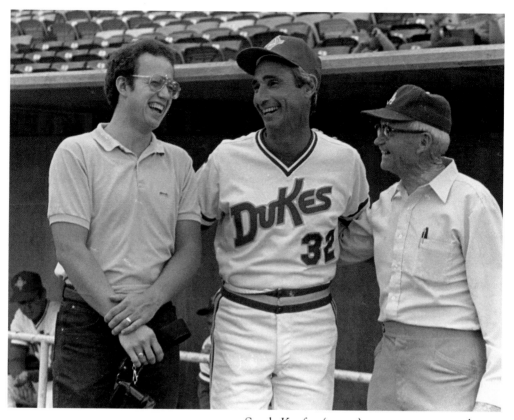

Sandy Koufax (center) was no stranger to the Albuquerque Sports Stadium, often providing advice to pitchers and pitching coaches. Here he chats with two fans who originally had been at Crosley Field in Cincinnati in 1966, hoping to get close to Koufax. Oddly, in May 1984, Ron Mansdoerfer (left) and Joe Foley—strangers to each other—were again hoping to get close to Koufax, this time in Albuquerque. Foley had a photograph from that 1966 encounter, and Mansdoerfer was in the background of that shot.

Former Dodgers' infielder Maury Wills, who stood the baseball world on its ear when he stole 104 bases in 1962, became a roving instructor for the Dodgers and came to Albuquerque on an annual basis to work with the young Dukes.

Del Crandall, who managed the Albuquerque Dodgers and Albuquerque Dukes, and also was the skipper for the Milwaukee Brewers when they played a preseason game at Albuquerque Sports Stadium in 1978, is interviewed here by the late Frank Maestas of the *Albuquerque Journal* before the Legends for Lobo Baseball Game in October 1988.

Yes, that really is Bob Gibson, seen here playing third base in the late innings of the Legends for Lobo Baseball Game in 1988. Gibson pitched two scoreless innings, was 1 for 1 at the plate, and later made an error at third. The man was a versatile athlete: a former basketball star at Creighton University, he also played briefly with the Harlem Globetrotters.

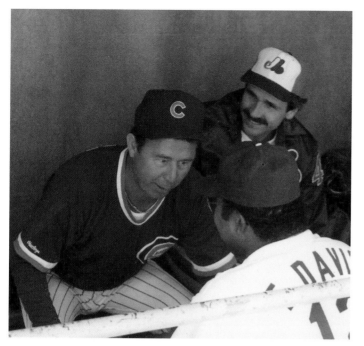

Former Chicago Cubs' third baseman Ron Santo leans over to tell a story to former Dodgers' outfielder Tommy Davis as one-time Montreal pitcher Steve Rogers listens. The ex-ballplayers were chatting in the Dukes' dugout before the 1988 Legends for Lobo Baseball Game. The NL team beat the AL squad 8-4 in the six-inning game. Bobby Bonds hit the game's only home run.

Frank Howard, the National League Rookie of the Year in 1960 when he broke in with the Los Angeles Dodgers, bats during the Legends for Lobo Baseball benefit game at Albuquerque Sports Stadium in October 1988. "Hondo," who went 1 for 1 in the exhibition contest, had last appeared at Albuquerque Sports Stadium in 1978 as a base coach for the Milwaukee Brewers in a preseason game.

In one of the most-bizarre occurrences at the Albuquerque Sports Stadium, on a night when Hall of Fame pitcher Bob Feller was signing autographs, the Vancouver Canadians refused to play the Albuquerque Dukes because their paychecks were late in getting to them. Feller kept on signing; Vancouver went on to beat the Dukes in the PCL Championship Series.

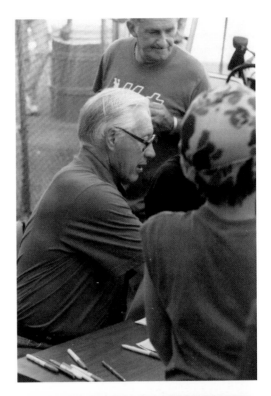

Legendary Negro Leagues ballplayer Buck O'Neil, the first African-American coach in Major League Baseball, visited Intel in Rio Rancho in 2004 during Black History Month, telling his usual funny stories from his life in baseball and leading Intel employees and executives in song. O'Neil was a contemporary of the legendary Leroy "Satchel" Paige and gained notoriety when he was featured in Ken Burns's nine-part documentary *Baseball*.

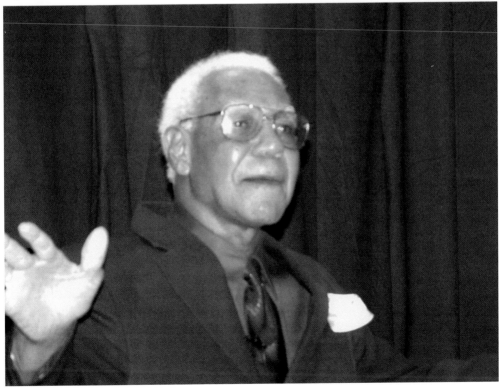

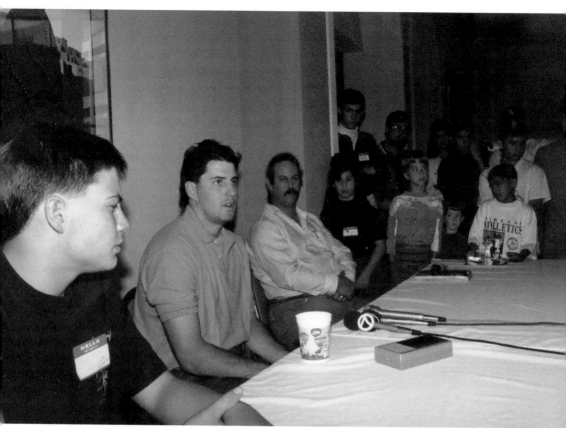

Hal Morris (second from left), the starting first baseman for the Cincinnati Reds when they beat the Oakland Athletics in the 1990 World Series, was the featured guest at Albuquerque's last major trading-card show in November 1990. The card-collecting craze in Albuquerque mirrored the nation's, but what had once been a dozen or so card shops in 1990 has since dwindled to a couple in 2010 thanks to the glut of sports trading cards manufactured in the early 1990s and the availability of cards and memorabilia on the Internet at sites like eBay. This particular show was held at the Holiday Inn Midtown, which has since been renovated and renamed MCM Elegante. Morris was a friendly guest, happily signing hundreds of autographs at the show. Card shows in recent years in Albuquerque have been few and far between.

Here are two of the Duke City's best homegrown ballplayers. John Roskos (at right) is seen in the batting cage in Peoria, Arizona, during spring training in 2001. He graduated from Cibola High School and turned down a full ride to play baseball at Louisiana State University when the Florida Marlins chose him in the second round of the 1993 draft. Roskos, a two-time PCL All-Star, played in 37 big-league games before retiring after not finding a roster spot with San Diego in 2001. Brendan Donnelly (below), a graduate of Sandia High School, signs autographs in Tempe, Arizona, before a Cactus League game. Donnelly spent 11 seasons in the minors before a promotion to the Anaheim Angels in 2002 and was the winning pitcher in Game 6 of the 2002 World Series. He also earned the victory for the AL in the 2003 All-Star Game.

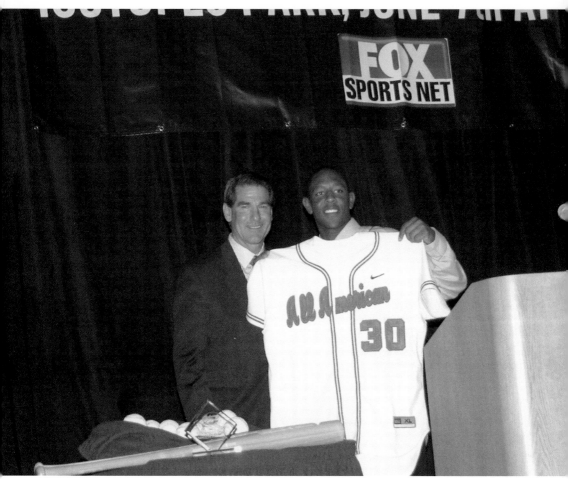

Former big-league first baseman Steve Garvey (left) beams as Georgia high school ballplayer Dexter Fowler shows off the uniform he would be wearing in the 2004 High School All-American Game at Isotopes Park. Six years later, Fowler was back at Isotopes Park, this time as a starting outfielder for the Colorado Rockies, who played a pair of preseason games there against the Seattle Mariners.

EXTRA INNINGS

Hall of Fame baseball journalist Tracy "Cowboy" Ringolsby (left) listens to a conversation between Colorado Rockies' manager Clint Hurdle (facing the camera) and Texas Rangers' manager Buck Showalter before a game at Isotopes Park in 2005. The big-league teams were joined that year by the Arizona Diamondbacks for a preseason round-robin series during Major League Weekend.

Former New York Yankees' and Arizona Diamondbacks' manager Buck Showalter, (right) answers a question posed to him by Tracy "Cowboy" Ringolsby before the Texas Rangers, then managed by Showalter, participated in Major League Weekend at Isotopes Park in 2005. Local baseball writers found Showalter to be a good interview.

What do Tony Clark and Tony Gwynn have in common, besides their first name? Both played basketball at San Diego State University and both were guests of Isotopes Park in its first few seasons. Gwynn was the head coach of the San Diego State baseball team, which played the University of New Mexico at the park, while Clark (seen here signing autographs) visited with the Arizona Diamondbacks during Major League Weekend in 2005.

Colorado Rockies' first baseman Todd Helton had played in Albuquerque before, back in 1997 when he was with the Rockies' Triple-A club at Colorado Springs and the Sky Sox were at Albuquerque Sports Stadium to play the Dukes. Although Albuquerque fans favor the Los Angeles Dodgers, there is a sizeable contingent who root for the Rockies in the Duke City, many of who traveled to Denver in April 1993 to see the Rockies' first MLB game there.

EXTRA INNINGS

Still an imposing figure, former Albuquerque Dukes' (1977, 1979, and 1980) pitcher Dave Stewart won 15 games in Albuquerque's 1980 championship season before going on to have a sterling big-league career. "Smoke" won World Series championship rings while with the Dodgers in 1981, the Oakland A's in 1989, and the Toronto Blue Jays in 1993. Stewart (168-129) was the featured speaker for the High School All-American Game in 2005.

Here is the view from the press box during the national anthem before one of the three High School All-American All-Star baseball games played at Isotopes Park from 2004 to 2006. Each of those games featured New Mexico ballplayers. Former La Cueva standouts James Parr and Jordan Pacheco played in an All-American game and went on to play professionally; Parr signed with Atlanta, and Pacheco signed with the Colorado Rockies. Justin Sellers, an All-American ballplayer with Rio Rancho ties, wound up playing for the Isotopes in 2010.

Seen here is another member of the Hall of Fame who visited the Duke City. Canadian Ferguson Jenkins, enshrined in Cooperstown in 1991, was a guest speaker during the 2007 All-Star Fiesta, entertaining fans and ballplayers at Sandia Resort and Casino's huge banquet hall. Jenkins was 284-226 in his major-league career (1965–1983), pitching for the Phillies, Cubs, Rangers, and Red Sox.

In what must have been a great thrill for a just-graduated high school ballplayer, former Rio Rancho High School standout Joey Garcia takes a mighty cut during the 2007 High School All-American Baseball Game's home-run derby at Isotopes Park. Two weeks earlier, Garcia and the Rams won the Class-5A baseball championship, which was played at Isotopes Park.

EXTRA INNINGS

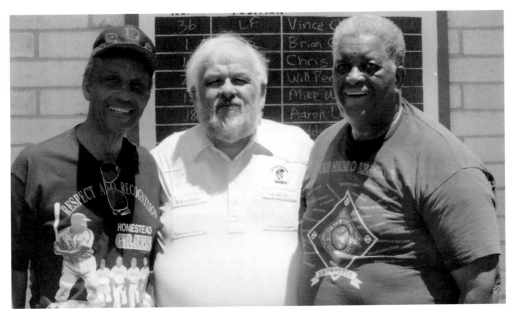

Longtime Albuquerque Dukes' president and general manager Pat McKernan is flanked by two former Negro Leagues ballplayers, Bill Beverly (left) and Joe Black, who was the National League Rookie of the Year in 1952. The two former ballplayers were on hand for "A Tribute to the Stars of Old Negro Baseball Throughout the Minor Leagues" in July 1996.

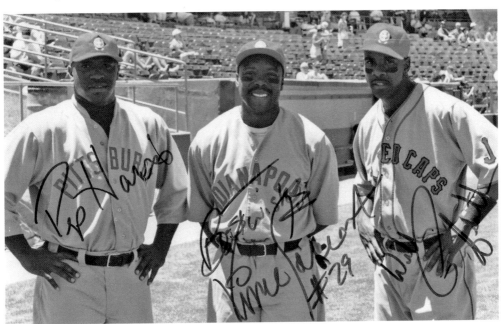

From left to right, Vancouver Canadians Pep Harris, former NL stolen-base champ Vince Coleman, and William Pennyfeather have donned uniforms patterned after those worn by Negro Leagues teams in the days before baseball was desegregated. The throwback uniforms were worn in July 1996 during the Albuquerque Dukes' Negro Leagues Appreciation Day.

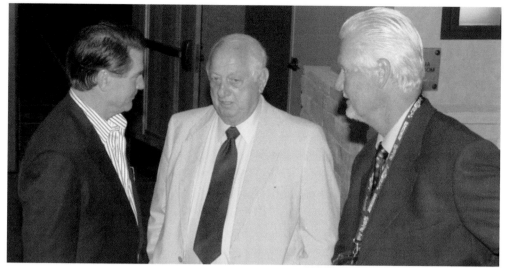

From left to right, former Dodgers' first baseman Steve Garvey, Hall of Fame manager Tommy Lasorda, and former major-league outfielder Tom Paciorek swap old ballpark stories while visiting the Duke City during Fan Fiesta. The event was held in conjunction with the Albuquerque Isotopes' hosting of the annual Triple-A All-Star Game in 2007.

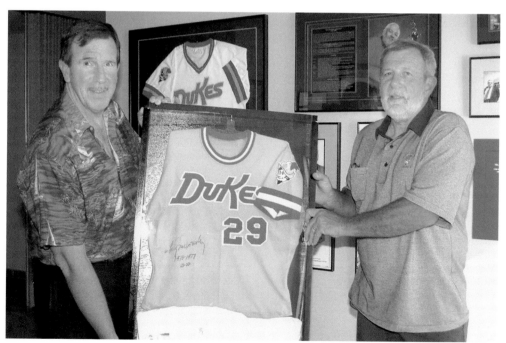

Baseball hobbyist Tracy Stambaugh of Los Lunas (right) presents former Albuquerque Dukes' catcher/first baseman Terry McDermott with one of his old jerseys at McKernan Hall. McDermott, who played with the Albuquerque Dodgers in 1971 and with the Dukes from 1973 to 1976, said that when he played in Albuquerque, the players did not get to keep their gear, although he admitted he still has some of his old cleats tucked away in a closet.

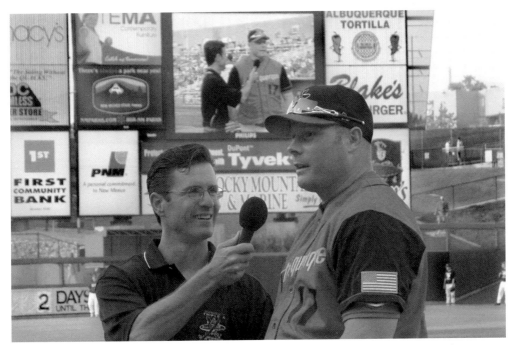

Albuquerque Isotopes' play-by-play man Robert Portnoy interviews former slugger Rob Stratton, an original Isotope from the 2003 season, after Stratton won the Triple-A All-Star Game's home-run derby in 2007. The video board in left field let the fans watch.

Baseball fan Loren Crites of Rio Rancho (left) did not mind waiting in line at the 2007 All-Star Fiesta to get the autograph of former Albuquerque Dukes' standout Mike Marshall, the PCL's Triple Crown winner in 1981.

Seen above, Albuquerque Professional Baseball Hall of Fame inductee J. D. Kailer wraps up his remarks at Isotopes Park during the 2008 ceremonies. At right is Patrick McKernan, son of the late inductee Pat McKernan, and next to him is former manager Del Crandall, inducted as the all-time winningest manager (1969, 1970, and 1978–1983) in Dukes' history. Featured in the photograph below are the 2009 inductees. From left to right, they are Tom Paciorek, one of the best players on the memorable 1972 Dukes; former pitcher Jesse Priest, who was married at home plate before a game at Tingley Field more than 50 years before; and former pitcher Dennis Lewallyn, who holds the all-time Albuquerque Dukes' records for games (232) and complete games (37).

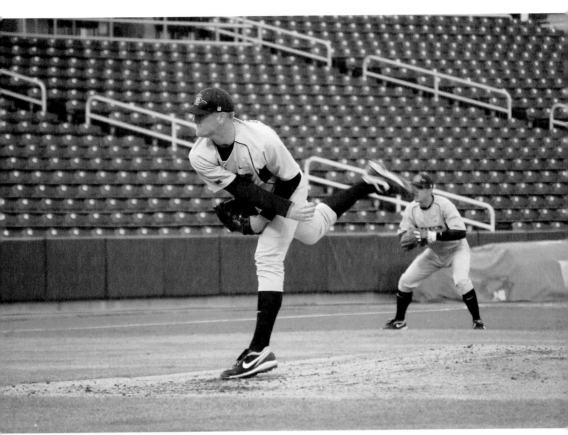

Probably the best pitcher to take the Isotopes Park mound in all of 2009, San Diego State University right-hander Stephen Strasburg shackled the UNM Lobos with a one-hit performance. Later he was the first overall pick in the amateur draft (taken by the Washington Nationals), and he eventually signed a record four-year, $15.1-million contract. Strasburg pitched in the minor leagues in what was left of the 2009 season and began the 2010 season there as well. He made his big-league debut in the nation's capital on June 8, 2010, with his fastball topping out at 100 miles per hour and striking out 14 Pittsburgh Pirates in seven innings of work, delighting the crowd of 40,315 that turned out to see it. Performances like that helped give lowly Washington national exposure and numerous televised ballgames. Unfortunately an arm injury shortened his 2010 season and was expected to keep him out of action for all of 2011. Fans in Albuquerque likely will not forget that chilly night in the spring of 2009 when they saw the youngster.

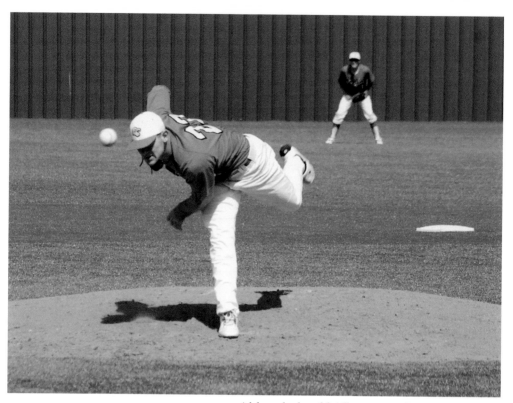

Although the old Albuquerque Sports Stadium and Isotopes Park are primarily used for professional and college baseball games, every May those parks are used for state high school playoff games, sanctioned by the New Mexico Activities Association. Although Eldorado High School southpaw Sam Wilson (seen here) and his Eagles did not win the 5A title in 2010, there is a chance that he will see future glory on the Isotopes Park mound as a pitcher for the University of New Mexico.

Another former prep standout from Albuquerque who is no stranger to Isotopes Park is former La Cueva and University of New Mexico standout Jordan Pacheco, seen here being interviewed on the field before the Colorado Rockies played the Seattle Mariners in April of 2010. Pacheco was drafted by the Rockies and changed positions from second base to catcher. He began the 2010 season at Single-A Modesto and finished at Double-A Tulsa with a .405 cumulative average.

Judging by what slugger Jason Giambi is wearing here, it looks like it was cold the day in April of 2010 when his Colorado Rockies were getting ready to play the Seattle Mariners. Fans did not know it at the time, of course, but Giambi would go on to play a key role for the Rockies, filling in for first baseman Todd Helton when his aching back took him out of the lineup in July.

Albuquerque baseball fans had the opportunity to see this probable future Hall of Famer, Ichiro Suzuki, in action at Isotopes Park when his Seattle Mariners played a pair of games with the Colorado Rockies in April of 2010. Known primarily by his first name, Ichiro was very accommodating when it came to signing autographs for the fans.

A sure-fire first-ballot entrant to baseball's Hall of Fame in Cooperstown, Ken Griffey Jr. (left) looks back from the batting cage at the arriving crowd before his Seattle Mariners face the Colorado Rockies in a pair of spring-training games at Isotopes Park in early April 2010. Griffey, who did not play in either game, announced his retirement from baseball in June.

Isotopes Park was packed with baseball fans eager to watch the Colorado Rockies face the Seattle Mariners in a pair of ballgames in early April of 2010. Here Rockies first baseman Todd Helton watches for a throw from his pitcher, wary of the speed of Mariners' runner Ichiro Suzuki.

Former Albuquerque Dukes' infielder Jack Perconte (left) listens to former Los Angeles Dodgers' manager Tommy Lasorda during the induction ceremonies for the Albuquerque Professional Baseball Hall of Fame in July of 2010. Perconte, a 2010 inductee, was a fan favorite when he played at Albuquerque Sports Stadium (1979–1981 and 1987). A member of championship teams in 1980, 1981, and 1987, Perconte held the record for multiple-hit games (173).

Former Albuquerque Dodgers'/Dukes' general manager Charlie Blaney is interviewed at Isotopes Park by Will Webber of the *Albuquerque Journal* in July 2010 before Blaney was inducted into the Albuquerque Professional Baseball Hall of Fame. At the time, Blaney was in the first year of a three-year contract as president of the California League.

Orbit, the popular fan-friendly mascot for the Albuquerque Isotopes, relaxes with fans in the left-field seats before a ballgame in 2009. Orbit has a high profile, often visiting area elementary schools and is the subject of annual coloring-book entries solicited by the team. In eight years of "Base Race" competition during ballgames, Orbit has yet to win a race against a youngster.

An entertainer at minor-league ballparks around the country, Rick "Myron Noodleman" Hader credits Pat McKernan, the late president and general manager of the Albuquerque Dukes, for getting his career off to a good start in 1993. Since that humble beginning at the Albuquerque Sports Stadium, he has been able to retire from teaching and travel around the country as a Jerry Lewis-like entertainer. (Myron Noodleman.)

The Albuquerque Dukes played their last game in 2000, but their popularity never waned, and longtime baseball fan and Duke City businessman Fred Matteucci bought the trademark from the Portland Beavers (would the Portland "Dukes" have been successful?) after the team was sold by Robert Lozinak to a group that moved them to the Pacific Northwest. The above photograph is of the stadium concourse during the annual Retro Night in 2010. In the photograph below, Orbit, the Isotopes' mascot, looks the same on the field from year to year, but his bobblehead issues seem to change; at left is a generic Isotopes bobblehead. Later manager Dean Treanor had his own bobblehead issued, the team gave away Manny Ramirez bobbleheads when the Dodgers slugger was in Albuquerque for a 2009 rehab assignment, and in 2010 a Tommy Lasorda bobblehead was offered, with Lasorda in the Dukes' uniform that the team wore in 1972 when he was the club's manager.

DISCOVER THOUSANDS OF LOCAL HISTORY BOOKS FEATURING MILLIONS OF VINTAGE IMAGES

Arcadia Publishing, the leading local history publisher in the United States, is committed to making history accessible and meaningful through publishing books that celebrate and preserve the heritage of America's people and places.

Find more books like this at
www.arcadiapublishing.com

Search for your hometown history, your old
stomping grounds, and even your favorite sports team.

Consistent with our mission to preserve history on a local level, this book was printed in South Carolina on American-made paper and manufactured entirely in the United States. Products carrying the accredited Forest Stewardship Council (FSC) label are printed on 100 percent FSC-certified paper.

MADE IN THE